SOMERSET'S MILITARY HERITAGE

Andrew Powell-Thomas

AMBERLEY

First published 2018

Amberley Publishing
The Hill, Stroud
Gloucestershire, GL5 4EP

www.amberley-books.com

Copyright © Andrew Powell-Thomas, 2018

Logo source material courtesy of Andrew
Powell-Thomas.

The right of Andrew Powell-Thomas to be identified
as the Author of this work has been asserted in
accordance with the Copyrights, Designs and Patents
Act 1988.

ISBN 978 1 4456 7698 2 (print)
ISBN 978 1 4456 7699 9 (ebook)

British Library Cataloguing in Publication Data.
A catalogue record for this book is available from the
British Library.

Origination by Amberley Publishing.
Printed in Great Britain.

Contents

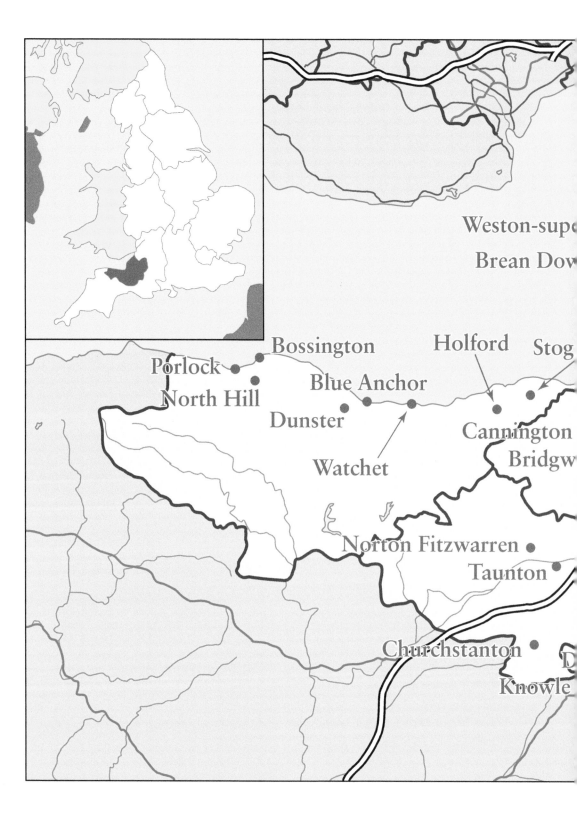

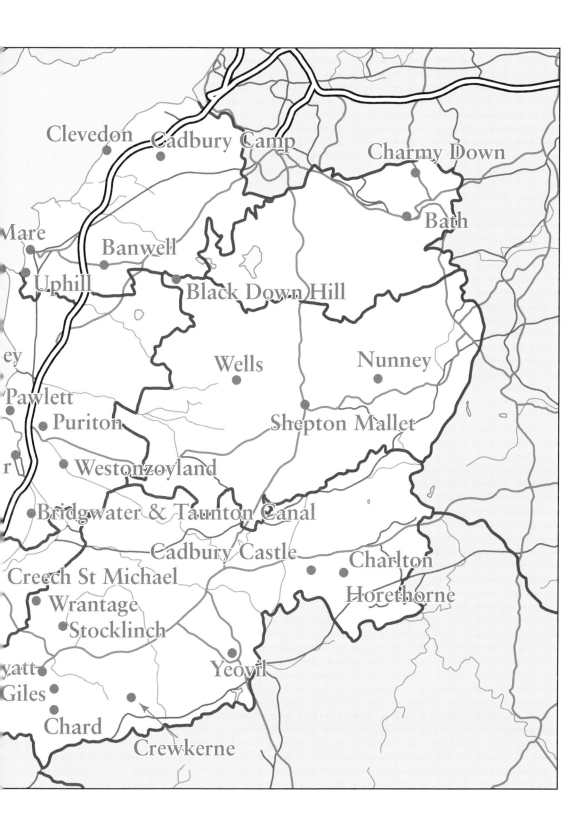

Clevedon

Cadbury Camp

Charmy Down

Mare

Banwell

Bath

Uphill

Black Down Hill

ey

Wells

Nunney

Pawlett

Puriton

Shepton Mallet

r

Westonzoyland

Bridgwater & Taunton Canal

Cadbury Castle

Charlton

Creech St Michael

Horethorne

Wrantage

Stocklinch

yatt

Giles

Yeovil

Chard

Crewkerne

Introduction

The rural county of Somerset, with its rolling hills, national parks, vast swathes of farmland and jagged coastline, has a somewhat unexpected rich military heritage. It would be easy to live and commute in Somerset and not see or appreciate the sheer range of history that lies all around, sometimes in plain sight, sometimes hidden in the hedgerow.

Iron Age hill forts, dating back to before 500 BC, blend into the landscape, thanks to the numerous natural hills that roll across the countryside. Huge castles, built by William the Conqueror in the eleventh century, are now, rightly, viewed as cultural highlights and it is easy to forget about their bloodthirsty past in keeping the local population in check. Battles fought between Royalist armies representing the King of England and local rebels are now just empty fields with livestock grazing peacefully. The names of hundreds of young men who set off from the quiet life in Somerset never to return from the horrors of the First World War are immortalised on the silent monuments that adorn nearly every town and village.

Then, of course, there's the Second World War and in particular the Taunton Stop Line. Containing around 400 structures, the Taunton Stop Line was a defensive wall that stretched approximately 50 miles across Somerset, a small part of Dorset, and a few miles of Devon. Almost all of the stop line remains intact today and the majority of Second World War emplacements that can still be found across the county belong to it. However, Somerset's Second World War legacy is not just limited to this. With secret research centres, huge armament factories, airfields and prisoner of war camps, there are many relics to be found.

Somerset's military heritage continues to the present day, with military camps and training centres still in use by Britain's armed forces.

This book aims to provide some background and insight into the range of localities right across the county, looking at their roles and what can be found there now. It is organised according to geographical location, using the seven established districts of Somerset.

1. North Somerset

Banwell

The village of Banwell has the 4-metre-high earthwork remains of a Bronze Age hill fort to the east, Banwell Camp, and the Victorian era Banwell Castle located within it. Although the castle was built as a home, in the Second World War it was taken over by the Royal Air Force and used as the headquarters for No. 955 Squadron. This was a barrage balloon unit and was no doubt linked to the barrage balloon testing facility at Pawlett.

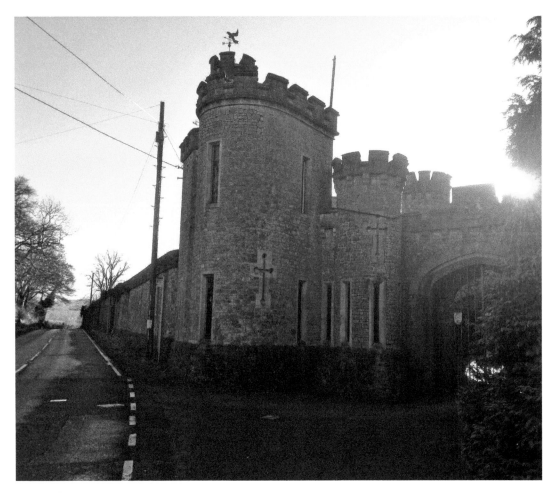

View of the gatehouse to Banwell Castle.

Brockley

The tiny village of Brockley, along the A370, seems an unlikely place for a prisoner of war camp, but during the Second World War POW Camp Number 403 was constructed here. All the buildings are long since gone, but it once housed 300 captured soldiers, initially Italian prisoners and later German prisoners from the Battle of Normandy.

Cadbury Camp

Cadbury Camp, located close to the village of Tickenham and the Limebreach Wood nature reserve, is a 7-acre Iron Age hill fort that consists of large ditches (approximately 2 metres deep) and banks of earth. Estimated to have been constructed in the sixth century BC, the site has a diameter of over 150 metres and the double-layer ramparts are well over 10 metres apart. Little is known about the reasons for its construction or the people who built it, but the few archaeological finds at the site suggest it was also likely used in the Roman era too. During the Second World War, a searchlight battery was stationed here to help locate enemy aircraft so that they could be shot down before bombing Bristol and the aircraft factory at Filton.

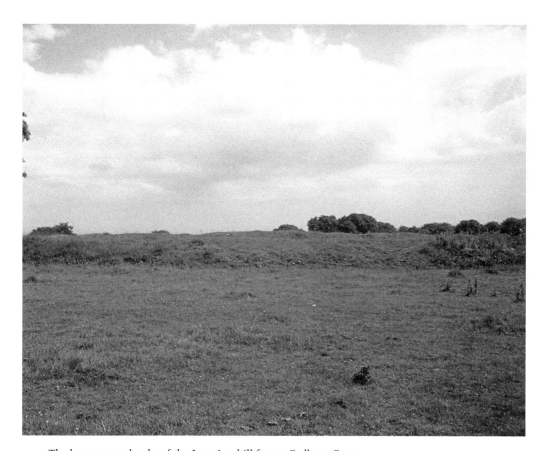

The large grassy banks of the Iron Age hill fort at Cadbury Camp.

Clevedon

The coastal town of Clevedon has a range of interesting sites around it, with the Grade II-listed Walton Castle being top of the list. Set on top of a hill to the north of the town, there is evidence to suggest it was once an Iron Age hill fort, and there is mention of it in William the Conqueror's Domesday Book in 1086, where it is recorded as belonging to 'Gunni The Dane', primarily being used as a hunting lodge. The footprint of the castle that is there today was built in 1615–20, but, after the English Civil War, it lay derelict for nearly 200 years from 1791 to 1979 before being restored. In west Clevedon, there are the remains of another Iron Age hill fort on Wain's Hill, where the great earthworks are still in situ, and due to this location having a commanding field of vision over the surrounding area, it is unsurprising to find a pillbox from the Second World War here too.

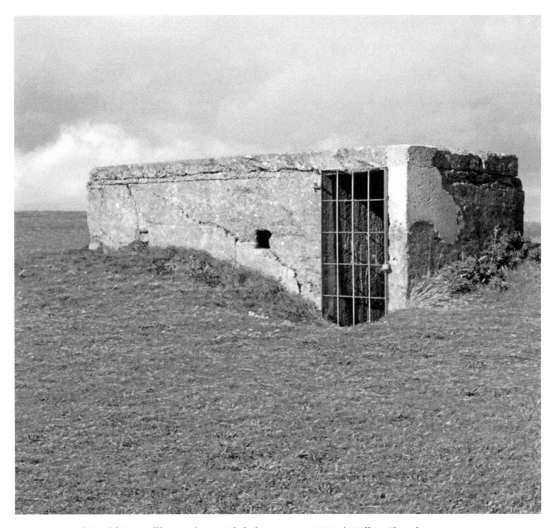

A Second World War pillbox and air-raid shelter sits atop Wain's Hill in Clevedon.

Lulsgate Bottom

In September 1940, the RAF established a relief landing ground by the hamlet of Lulsgate Bottom. Initial plans were for the airfield to be used in an experimental capacity, but it soon became a satellite airfield for RAF Colerne in Wiltshire. A bizarre incident occurred on 24 July 1941 when a German Junkers Ju88 actually landed at the airfield after confusing the radio beacon in Lympsham for a Luftwaffe beacon in Brest, France. This site is now the location of Bristol International Airport.

Portishead

Portishead, a town of around 25,000 at the very edge of North Somerset, has a history dating back to Roman times. Built on the Severn Estuary and near the mouth of the River Avon, the name itself derives from 'port at the head of the river' and Portishead has been a strategically important settlement. From as far back as Tudor times a fort was established and this was used to overlook the deep water shipping channel of the River Severn and protect Bristol. Interestingly, ocean-going ships pass closer to land at 'Battery Point' than at any other part of the British coastline. During the English Civil War, the Royalists used the fort but this fell into the hands of Parliamentary commander-in-chief Thomas Fairfax in 1645. The fort was used during the Napoleonic Wars, with guns and barrack blocks being constructed, and it later became a Victorian coastal battery. In the First World War, underground ammunition stores were added, and during the Second World War, the battery at Portishead was specifically upgraded to defend the entrance to Avonmouth Docks, which contained searchlights, barracks, pillboxes and two 6-inch guns capable of hitting targets over 10 miles away. Today, only the concrete bases for the searchlights remain, along with some pillboxes.

Steep Holm

The kilometre-long island of Steep Holm has to be the most remote part of Somerset, and owing to its location in the Bristol Channel, it is not surprising that there has been a long military presence on it. In 1865 work began on building a Palmerston fort on the island, which formed part of the country's strategic coastal defence system during the Napoleonic Wars. Completed in 1869, there were six gun emplacements, a master gunner's house, barracks, a water tank and even a small inn. Military control of the island remained until 1908, when it was leased out, but was soon requisitioned back in the First World War, where the facilities were updated. At the outbreak of the Second World War, the existing fortifications were upgraded, including the building of a new jetty, searchlight batteries and even an underwater telegraph cable connecting it to Brean Down Fort. After the war, the military ceased operating on the island but many of the islands structures remain.

Uphill

Uphill, a small village at the southern end of Weston Bay, had three pillboxes constructed during the Second World War in order to protect the point where the River Axe flows into the Bristol Channel. There is a circular pillbox built against the sea wall and it is faced in the same stone in order to camouflage it.

Steep Holm gun emplacement. (Courtesy of Matt Neal under Creative Commons 2.0)

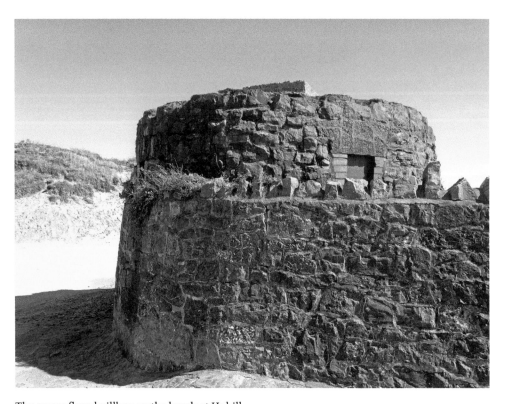

The camouflaged pillbox on the beach at Uphill.

Weston-Super-Mare

Weston-super-Mare, today the administrative headquarters of North Somerset with over 70,000 people, was just a small village up until the nineteenth century. Just to the north of the town there was once an Iron Age hill fort at Worlebury Camp, and in Worle itself, there once stood 'Castle Batch', a Norman motte-and-bailey castle thought to have been built in the years immediately after the Battle of Hastings. Both sites are now nothing more than open parkland protected as Scheduled Monuments. Locking Castle is another motte-and-bailey structure that once stood on Carberry Hill to the east of the town, and this site was used as the location of RAF Locking, a technical training centre constructed in 1937 and used right up until 1999, when it was demolished. Another RAF site existed in the town, with RAF Weston-super-Mare opening in 1936 and being used as a relief airport and training facility during the Second World War. In April 1944 it was used as the Polish Air Force Staff College, and after the war it was used by 'Westland Helicopters' right up until 2002, when the site was chosen to house the 'Helicopter Museum'. There are a number of pillboxes associated with the defence of these two sites still standing in the surrounding hedgerows. The Second World War also saw an influx of evacuees from the big cities to escape the bombing, but with the town being on the return route from Bristol and having its own important aircraft-related war industries, such as the Bristol Beaufort aircraft factory at Old Mixon, Weston-super-Mare received more than its fair share of bombing raids, with over 120 civilians losing their lives over the course of the war. As a result, the Air Ministry established a decoy station to the south of the town, in the small village of Bleadon, in order to divert the Luftwaffe. In 1941, Birnbeck Pier

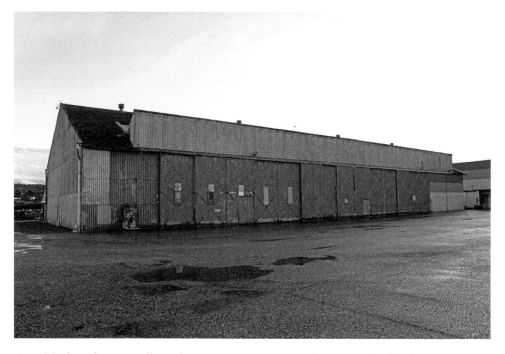

One of the large hangars still standing at Weston-super-Mare. (Courtesy of Richard E. Flagg)

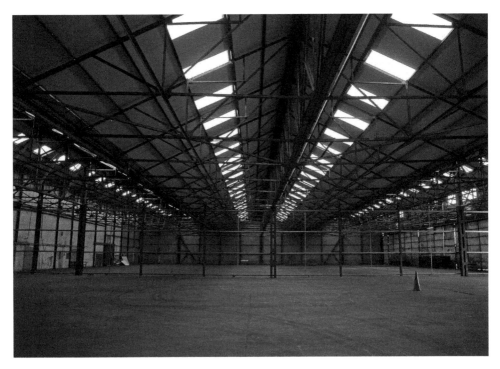

Inside the vast hangars. (Courtesy of Richard E. Flagg)

The derelict remains of a control building. (Courtesy of Richard E. Flagg)

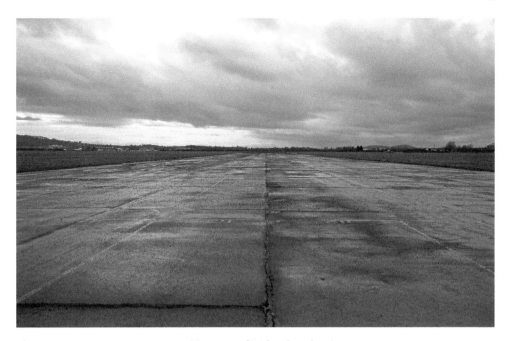

The runway at Weston-super-Mare. (Courtesy of Richard E. Flagg)

was requisitioned by the Admiralty, closed to the public and commissioned as HMS *Birnbeck* – a secret weapons testing facility. Here, scientists trialled many new and inventive weapons, such as 'Baseball', the naval version of the bouncing bomb, as well as trials to test the unwinding of the pipe line for PLUTO (Pipe Line Under The Ocean) in order to supply the Normandy beachhead with petrol in the days, weeks and months after D-Day.

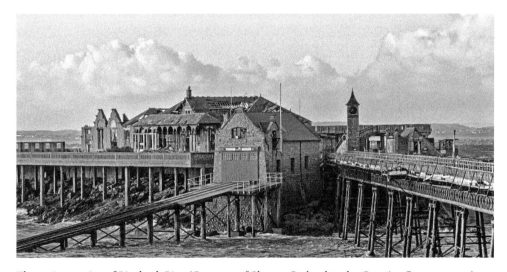

The eerie remains of Birnbeck Pier. (Courtesy of Sharon Garland under Creative Commons 2.0)

2. Bath and North East Somerset

Bath

The city of Bath, with its famous Roman baths, has had a long history of conquest and habitation. Established as a shrine by the Britons, it is thought that the Romans built a temple and defensive walls around it around the third century. In the years after Roman rule failed, Bath may have been the site of the Battle of Badon in AD 500, where King Arthur defeated the Anglo-Saxons, and the Battle of Deorham in 577 when it was captured by the West Saxons. When William the Conqueror died, Bath was just one town ransacked during the resulting 1088 rebellion, and during the English Civil War (1642–51) a small fortune was spent on fortifying the town and its garrisoned army belonging to Charles I. However, Bath quickly fell into the hands of the Parliamentarians, but was such an important location that the Royalists mustered more troops, which resulted in the Battle of Lansdowne occurring on the edge of the town on 5 July 1643. Initially the Parliamentarians held the high ground of Lansdowne Hill, but were forced to retreat and the Royalists once again took control of the town. During the Second World War the town became the home to the Admiralty's warship design programme, and was largely untouched by German bombs as it had no sizeable industrial significance, but that changed over the weekend of 25–27 April 1942. The Bath Blitz was part of Nazi Germany's 'Baedeker Raids', where cities of cultural significance were targeted in response to the growing success of the RAF's own raids in Germany. Over seventy-five aircraft dropped bombs on Bath that weekend, resulting in over 400 civilians being killed, over 1,000 injured and a staggering 19,000 buildings being affected.

Charmy Down

In 1941, the Royal Air Force built a 'Class A' airfield at Charmy Down, a few miles to the north of Bath. With its three runways, twelve hangars and myriad of other buildings, the RAF used the aerodrome as a base for night-fighter squadrons, who would intercept the German air raids on nearby Bath and Bristol. By 1943 the US Airforce occupied the site right up until the end of the war, and by 1946 the site was no longer in use. There are various buildings remaining on the site in various states of repair.

Chew Magna

Chew Magna regularly saw bombs falling within its parish boundary during the Second World War, thanks to the construction of a 'Starfish site' between North Chew Farm and Manor Farm. RAF personnel were responsible for lighting flares and beacons to lure German bombers into thinking it was part of Bristol and unleash their payload onto the countryside. Chew Hill was the site of an actual anti-aircraft gun emplacement, and the manor house at Chewton Priory was used to billet troops.

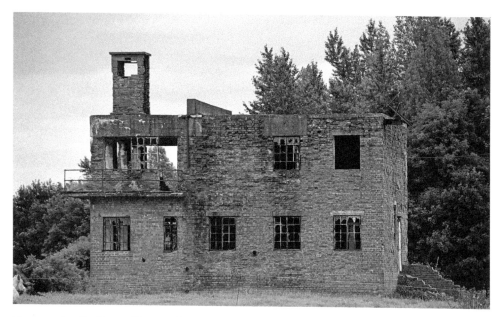

The now derelict Control Tower of RAF Charmy Down. (Courtesy of Richard E. Flagg)

The visible remains of one of the airfield's defensive pillboxes. (Courtesy of Richard E. Flagg)

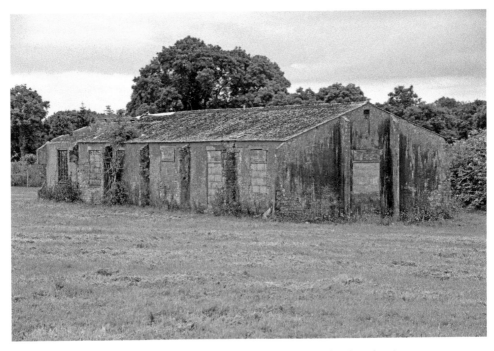

The lubricant and inflammables storage building. (Courtesy of Richard E. Flagg)

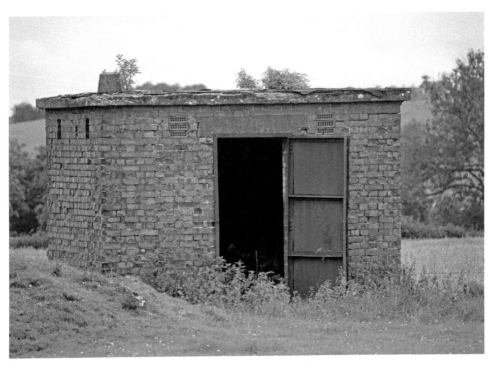

An auxiliary building within the airfield. (Courtesy of Richard E. Flagg)

The earthwork remains of Culverhay Castle. (Courtesy of Rick Crowley under Creative Commons 2.0)

Englishcombe

The small village of Englishcombe is home to the remnants of Culverhay Castle. The site once consisted of a stone keep and outbuildings, but now only the banks and earthworks remain, and little is known about its history.

Woolley

Hidden in the hills to the west of Bath, the tiny village of Woolley is one of only thirteen villages in the whole of England and Wales to be dubbed 'Doubly Thankful'. These few villages saw all those who served in both First World War and Second World War come home again safely, and this feat is marked in the church with two brass plaques: one for the thirteen who fought in the First World War and the other for the fifteen men who served in the Second World War.

3. West Somerset

Blue Anchor

The delightfully named Blue Anchor has a large Second World War pillbox built into its sea wall at the western end of the beach, probably positioned to defend the nearby railway station and level crossing. It is also at the start of the West Somerset Coast Path, which winds its way towards Dunster beach. By walking along this path it is possible to make out a further five pillboxes constructed in fields protecting the railway line.

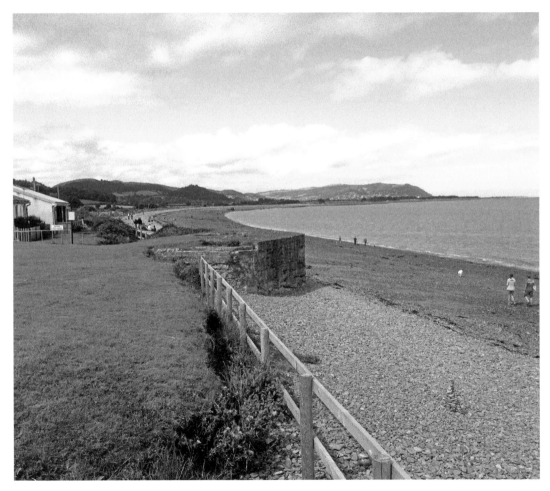

The long sweeping beach at Blue Anchor needed defending from potential enemy invasion during the Second World War.

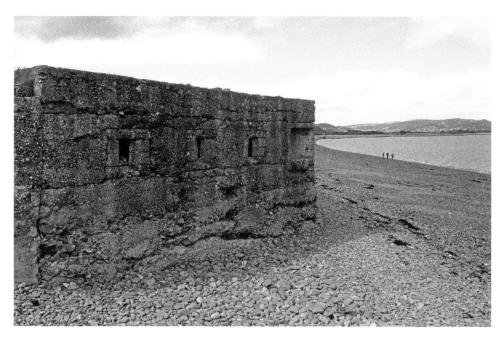

A close-up of the large pillbox with multiple gun embrasures facing out towards the Bristol Channel.

Bossington

The large shingle beach at Bossington is pretty isolated except for two pillboxes constructed during the Second World War and camouflaged in the same pebbles as the beach itself. The need to defend this stretch of coastline is evident by the sheer vastness of the pebble beach.

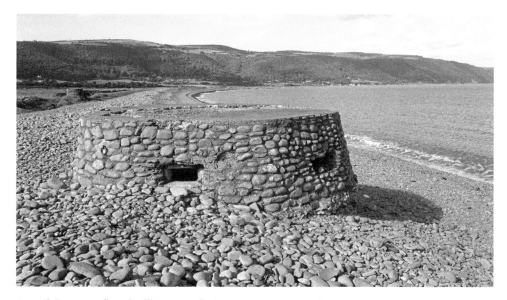

One of the camouflaged pillboxes on the huge Bossington Beach.

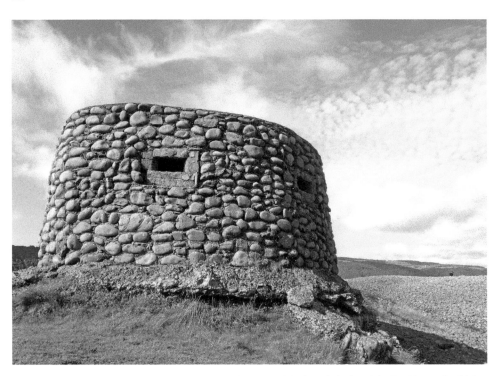

The second pillbox at Bossington is actually at the rear of the beach, behind the build-up of pebbles.

It is possible to easily explore the inside of the second structure, as it remains in very good structural condition.

Dunster

Dunster has a long and established military heritage that first dates back to a selection of Iron Age hill forts in the area such as Bat's Castle and Black Ball Camp, whose earthworks still remain today. In the aftermath of the Norman Conquest of 1066, William the Conqueror's tenant-in-chief, William I de Moyon, became the Sheriff of Somerset and built Dunster Castle on the top of a hill by the time the Domesday Book was written in 1086. Originally built of wood, a stone keep was soon built, along with towers and many buildings, as the castle acted a point of power for the de Moyon family for the next 400 years. During the English Civil War in the 1640s, the castle switched hands between the Royalists and Parliamentarians a number of times. Thomas Luttrell, the owner of the castle, supported the Parliamentarians and drove back an attack by the Royalists in 1642, who regrouped and attacked a year later in 1643, when Luttrell surrendered and swapped sides. However, in 1645 Robert Blake led a Parliamentarian 'Siege of Dunster' and installed a new garrison in 1646, who stayed in control for the next four years before partially destroying some parts of the castle. In the centuries that followed the upkeep of the castle proved to be very expensive, and it saw little by way of military action as it became more of a grand home. By the time of the Second World War, parts of the Dunster estate, including the castle, were used as a convalescent home for injured naval officers. On Dunster beach, two pillboxes were constructed (still standing today) and a camp

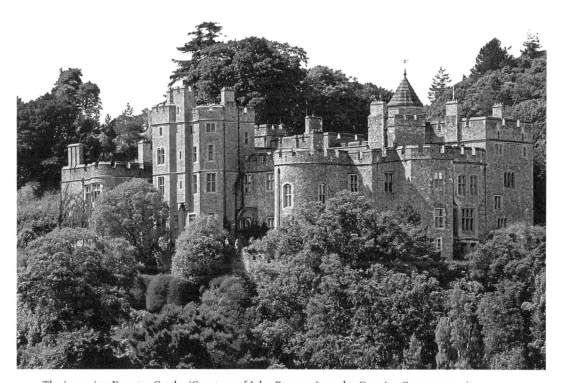

The imposing Dunster Castle. (Courtesy of John Parsons Jr under Creative Commons 1.0)

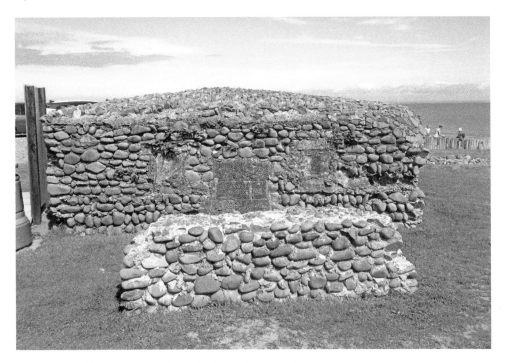

A Second World War pillbox right at the front of Dunster Beach.

Another pillbox in a much worse condition can be found towards the entrance of the car park.

The entrance to the ROC bunker at Holford.

complete with Nissan huts was set up for the military, who were building the coastal defences in the area. Today, Dunster castle is run by the National Trust.

Holford

In 1943 the small village of Holford was home to the US 40th Tented General Field Hospital in a specially built camp within the grounds of Alfoxton Park until July 1944, when they were moved to France. Over on Kilton Hill, the Royal Observer Corps (ROC) had a monitoring area to assist 'lost' aircraft during the Second World War, which was then used as a nuclear monitoring station in the Cold War right up until 1991. The access shaft to the underground bunker is still visible to the rear of a small parking area.

Minehead

Although the largest town in West Somerset, Minehead's only notable military heritage is from the Second World War when the town was used to house evacuees from the big cities being bombed in the Blitz. Significant for its harbour, Minehead established pillboxes and a coastal battery, which no longer exists. Minehead and its surrounding area would have also played host to an influx of American soldiers, training on nearby Exmoor.

North Hill

North Hill, on the eastern edge of Exmoor, has been a military site for a long time. With small traces of an Iron Age settlement, it was used as a training camp by the army in the 1800s and right up to the First World War. In 1942, it was again put under military control and became the Minehead Armoured Fighting Vehicle Range, one of just five large-scale firing ranges established across the country. Canadian soldiers were initially used to construct the storage rooms, marshalling areas, Nissen huts, trenches and associated buildings, and by 1943 the site was used exclusively by the US Army in the build up to D-Day as their tank crews honed their skills. The concrete tracks they used, along with the loading bay, marshalling area and some of the foundations of buildings are still visible today. There are also the remains of a radar station at North Hill, which operated from 1942 to 1946. Part of a chain of over 200 radar stations, all information collected was plotted, processed and passed onto bases and pilots. The concrete building that sits on North Hill today was the Operations Control building and would have had an antenna on top of its roof that rotated around 360 degrees, although this no longer exists at the site.

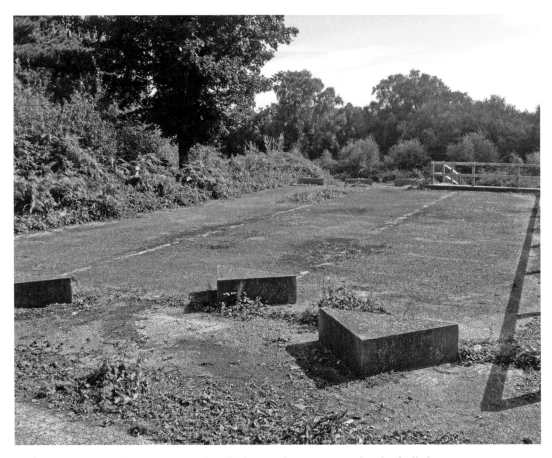

The tank marshalling area on North Hill where tanks were serviced and refuelled.

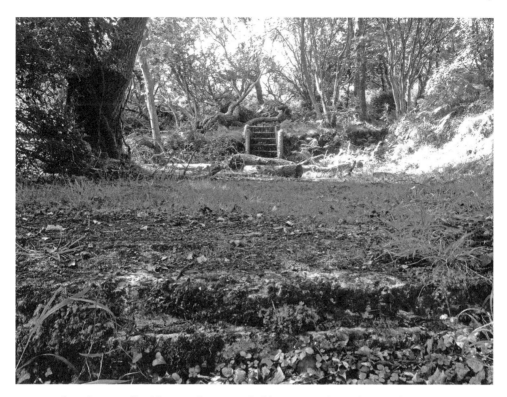

Concrete foundations of buildings and steps are hidden among the undergrowth.

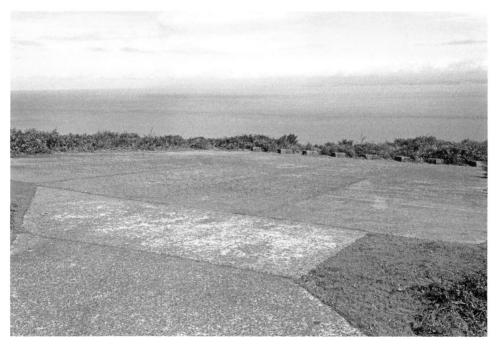

One of the tank firing ranges at North Hill.

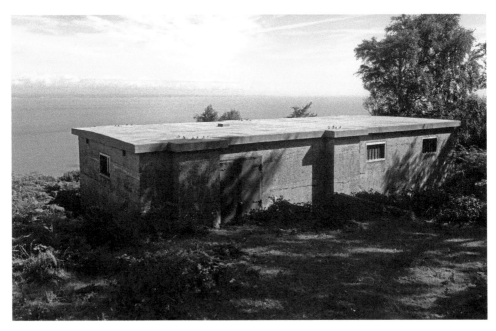

The Radar Station Operations Control building occupies a glorious position overlooking the Bristol Channel.

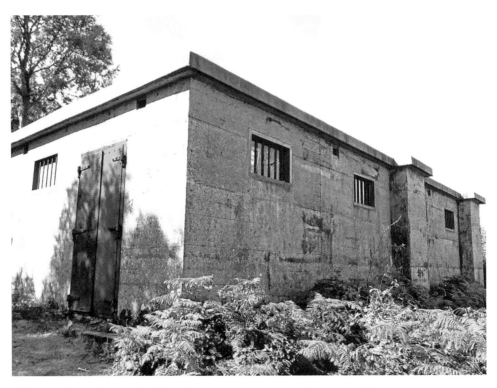

Still in good condition, the building is over 10 metres long and 5 metres wide.

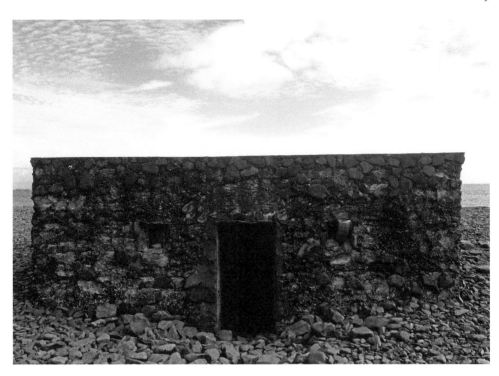

One of the pillboxes at Porlock Weir survives in reasonable condition on the pebble beach.

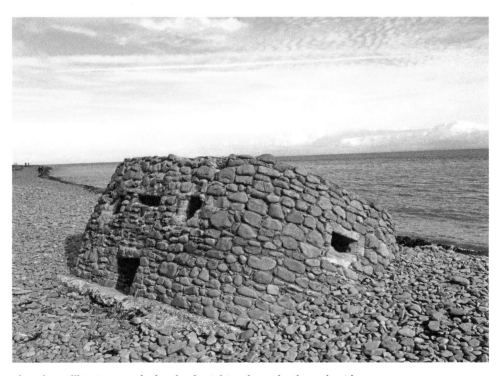

The other pillbox is not so lucky, slowly sinking down thanks to the tide.

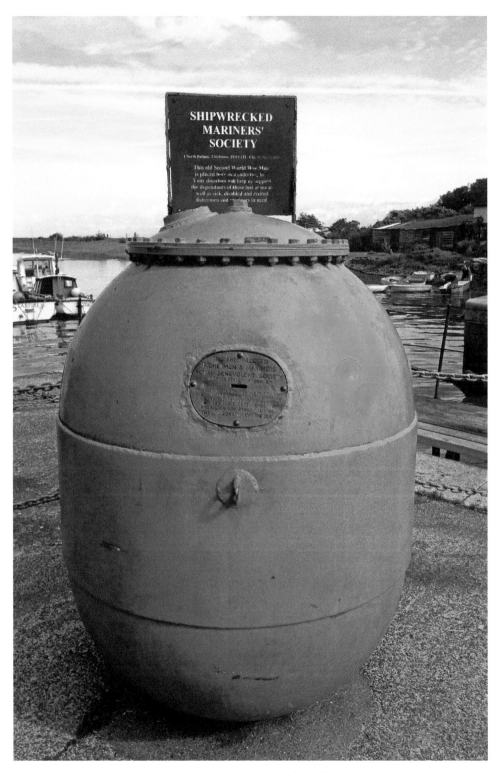

The old Second World War mine at Porlock Weir, now used to collect charitable donations.

Porlock

To the east of Porlock, a coastal village to the west of Minehead, are the earthworks of Bury Castle, an Iron Age hill fort that has steep drops surrounding it. At Porlock Weir, over a mile from the village itself, are the remains of two Second World War pillboxes, and an old Second World War mine is used to collect charitable donations.

Selworthy

Near the village of Selworthy are the earthwork remains of Bury Castle, an Iron Age hill fort built by Bury Wood. The simple circular enclosure is protected by the National Trust and is open to the public all year round.

Stogursey

Stogursey Castle is a motte-and-bailey castle built in the village of Stogursey on the Quantock Hills. Built around 800 years ago, it still retains its water-filled moat. During the War of the Roses in the 1450s, the castle was destroyed and left to ruin for the next 200 years or so, before a house was built inside it. Although the castle was left

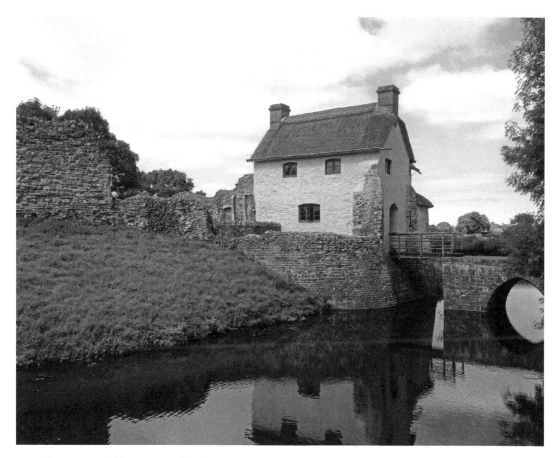

The remains of the motte-and-bailey Stogursey Castle.

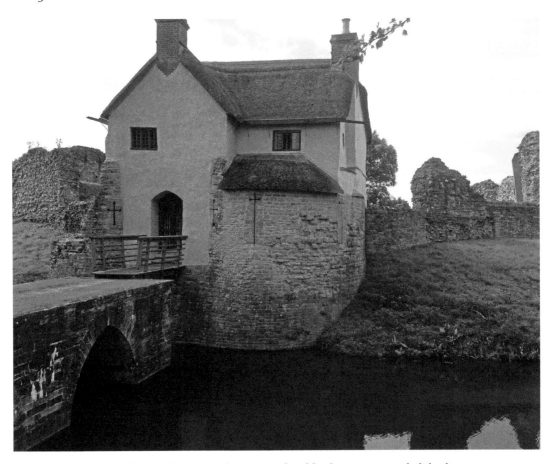

The old gatehouse has now been turned into a comfortable place to stay as a holiday home.

in its dilapidated state, the house was rebuilt and it is now available to stay in as a holiday home.

Watchet

Watchet was once home to a military camp on the clifftops, now occupied by Doniford Bay Holiday Park. Originally established in the 1920s, the site was used to train anti-aircraft artillery and by the 1930s over 30 acres were being used. For the target practice, a pilotless plane called the *Queen Bee* was catapulted from the shore. At the start of the Second World War Doniford Camp was handed over to the RAF, where the training continued, with just the occasional 'real' target being spotted and shot at. There was also an unusual dome-shaped building, known officially at the time as the Official Fire Control (OFC), but it was actually an early radar used for training purposes. Its circular concrete platform still exists in the holiday camp, being used as a car park. After the war, Doniford Camp remained as an RAF gunnery school until the late 1950s, when it was handed over to the Army as an infantry training centre. It remained operational until it was officially closed

in 1982. Just to the west of Watchet are a few earthwork remains of Daws Castle, an Iron Age hill fort that was then said to have been rebuilt by King Alfred around the year 900. Very little remains of this site due to erosion of the cliff faces and the building of the B3191 road.

4. Sedgemoor

Brean Down

Due to its prominent position, Brean Down has a long military history and is certainly one of the most spectacular settings in Somerset. Iron Age artefacts have been found on the strip of land that protrudes into the Bristol Channel and they are now on show in the Museum of Somerset. In 1864, construction started on a Palmerston fort, designed by Lord Palmerston at the bequest of Queen Victoria who was concerned about the strength of the French Navy, and positioned to help protect the approaches to Bristol and Cardiff. Taking seven years to build, the fort was staffed by around fifty soldiers of the Royal Artillery Coast Brigade and had seven 7-inch muzzle-loading guns, which could fire almost 1,000 metres and weighed over 5 tons. However, the fort was never used in action and it closed in 1900 when No. 3 magazine exploded. At the outbreak of war in 1939, the fort was rearmed with two 6-inch naval guns as it became a coastal battery that also had searchlights, anti-aircraft guns and a range of pillboxes. Manned by 365 and 366

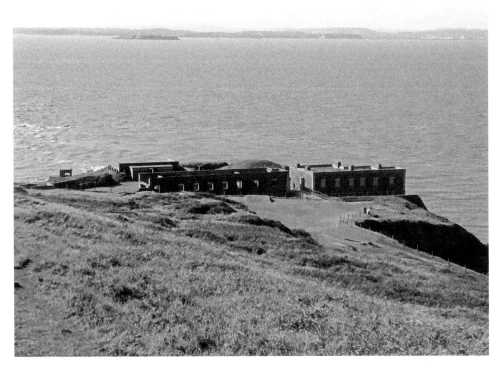

The spectacular setting of Brean Down Fort.

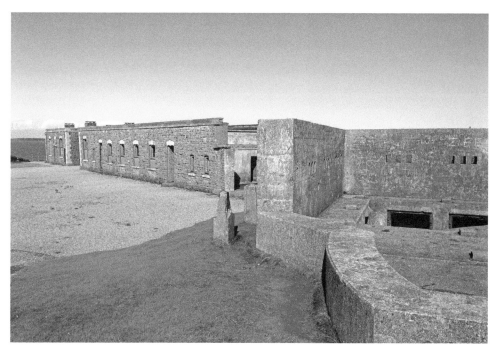

This Palmerston fort was built in 1864 to protect the approach to Cardiff and Bristol against the French Navy.

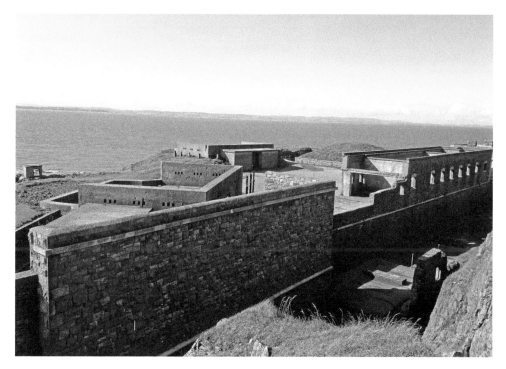

A large number of structures remain in situ.

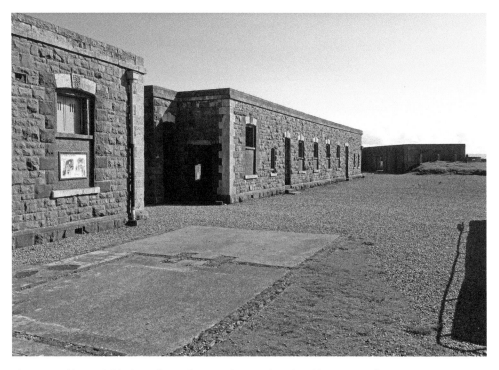

The original barrack blocks still stand strong despite the often blustery conditions.

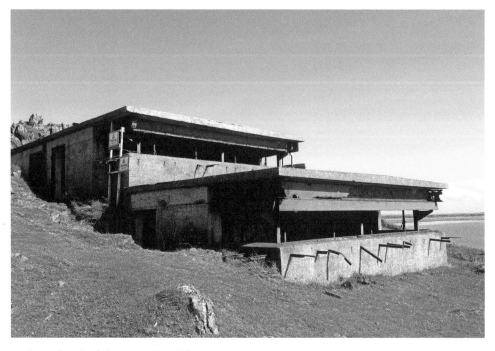

At the outbreak of the Second World War Brean Down became a coastal battery and a number of additional buildings were constructed.

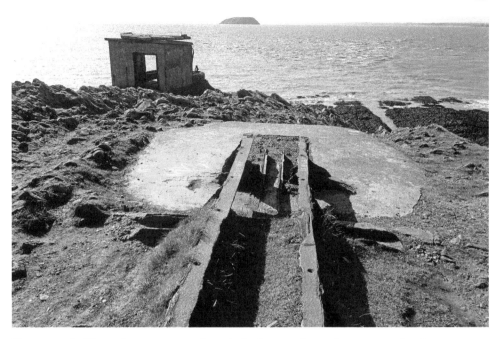

The very end of Brean Down was a test launch site for experimental weapons and rockets.

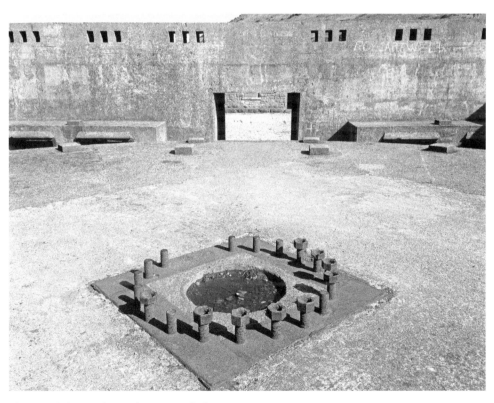

The site of the 6-inch naval guns is still clear.

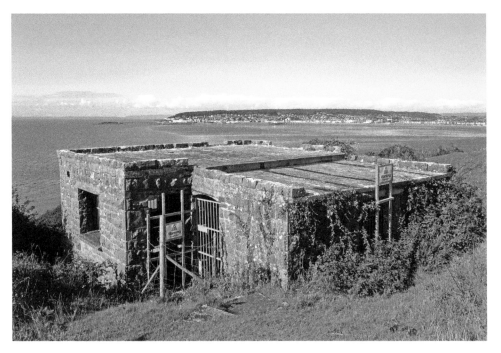

A pillbox overlooking the beach of Weston-super-Mare.

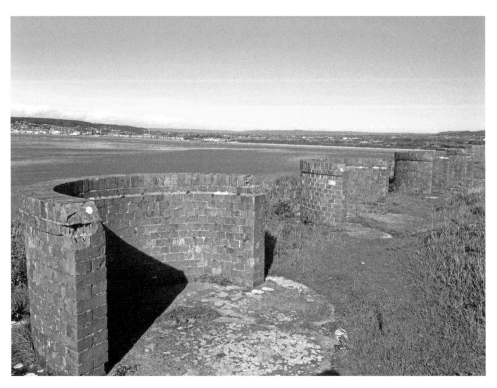

Some of the six Lewis gun emplacements on the northern cliffs overlooking Weston-super-Mare.

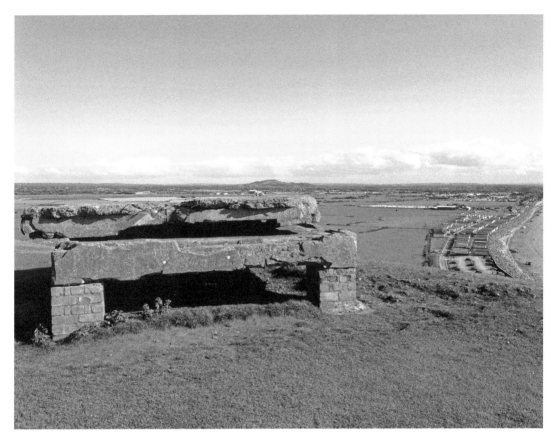

A Second World War pillbox overlooking miles of countryside on the southern cliffs.

Royal Artillery Coast Batteries of 571 Coast Regiment, it was also a test launch site for experimental weapons and rockets until the end of the war in 1945. At the other end of Brean Down, there are six Lewis gun emplacements on the northern cliffs overlooking Weston-super-Mare. It is now in the safe hands of the National Trust and is well worth a visit, with much still in situ.

Brent Knoll

Brent Knoll is an Iron Age hill fort over 100 metres high that has had human settlements on it since before 2000 BC! Well over a hectare in size, it has a single ditch around it as well as a range of ramparts. Located to the south of Burnham-on-Sea and looked after by the National Trust, it dwarfs the landscape surrounding it and is easily visible from the M5 motorway. There is evidence that the Romans used the site, with coins, roof tiles and painted wall plaster all being found, and these items are on display at Museum's in Taunton, Bridgwater and Weston-super-Mare. The knoll is also thought to be the site of the 875 battle between the Anglo-Saxon kingdom of Wessex and the Great Viking (Heathen) Army. It is no surprise that Brent Knoll was used during the Second World War as an anti-aircraft gun emplacement.

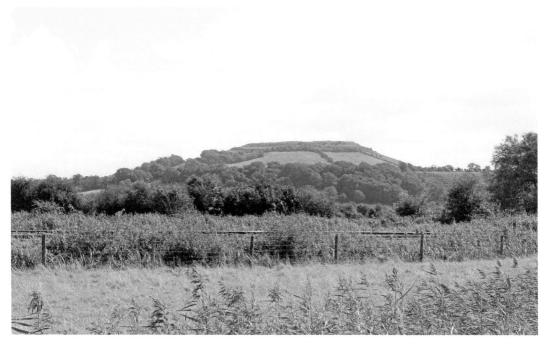

The Iron Age hill fort of Brent Knoll.

Bridgwater

Bridgwater, the largest town in the Sedgemoor district, is located just 10 miles from the mouth of the primary waterway in Somerset, the River Parrett, and has a long and established heritage. Mentioned in the Domesday Book due to its standing as a trading centre, it was a little over 100 years later in the year 1200 when King John granted a charter to construct Bridgwater Castle. Finally completed in 1220, it provided the Lord of the Manor of Bridgwater, William Brewer, a grand and imposing base with which to expand the town – and his own wealth! The castle was built on the only raised ground in the town, and as well as controlling the crossing of the town bridge, it also had a water gate, allowing access to the vital quay. Covering over 8 acres, the castle utilised the River Parrett by having a tidal moat, which is believed to have been up to 20 metres wide in places. Documents show there was a dungeon, chapel, tower and stables within the walls of the castle, and over the years further towers were added. As well as keeping the local population in check, there are some notable moments in the castle's history. During the Second Baron's War, fought against Henry III between 1264 and 1267, Bridgwater Castle was held by the barons against the king. The castle remained in the hands of the Mortimer family and in the Despenser War of 1321, the crown, on behalf of Edward II, occupied the castle until 1326 to stop Roger Mortimer using it. After this, the upkeep of the castle started to wane, and by 1548 it was in part ruin. Despite this, in 1642 the English Civil War broke out, and a garrison was established at the castle, led by Royalist Edmund Wyndham. He remained governor of Bridgwater until the town and castle fell to Oliver Cromwell and his Parliamentarians on 21 July 1645. By now the castle was in poor condition, and by

the time of the Monmouth Rebellion in 1685, very little remained, which led to rebel troops refortifying the town when they became hemmed in on 3 July 1685. The ruins of the castle were gradually demolished and replaced with new buildings. Sadly, very little remains of this once vast stronghold, save for a portion of the wall and water gate located on West Quay. The modern-day streets of Bridgwater now bear reminders of this grand past, named as they are King Square, Queen Street, Northgate and Castle Moat.

Bridgwater was one of the main 'defensive strongholds' of the Taunton Stop Line during the Second World War, and with a population of around 20,000 in 1941, it is no surprise that Bridgwater had its own unit of the Home Guard. Led by Lieutenant-Colonel R. Chamberlain, some 2,500 men were split into platoons that would patrol the various locations and positions of the stop line. Throughout the town, anti-aircraft emplacements and strategically placed pillboxes and roadblocks would have formed a solid base with which to hold up any invasion. The vast majority of the town-based defences have long since gone, with the rebuilding and restructuring of the town over the past decades causing them to be demolished. However, there are a few grand relics near Bridgwater train station that still stand tall today. Two pillboxes, at either end of the road bridge that straddle the railway track, stand two stories high and overlook the train station, as well as there being three anti-tank blocks still in existence on the other side of the road. Measuring just over 1 metre in their dimensions, thousands of anti-tank cubes were made out of reinforced concrete, and placed to hinder the progress of heavy armour. To the

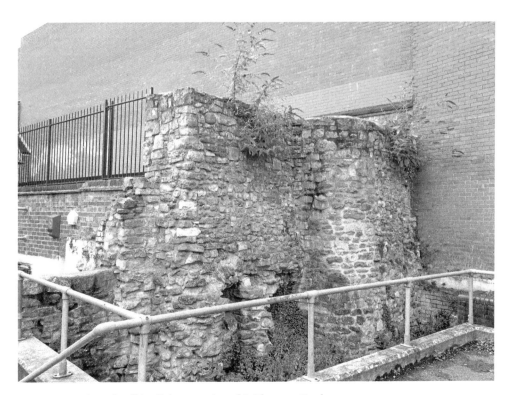

A 4-metre section of wall is all that remains of Bridgwater Castle.

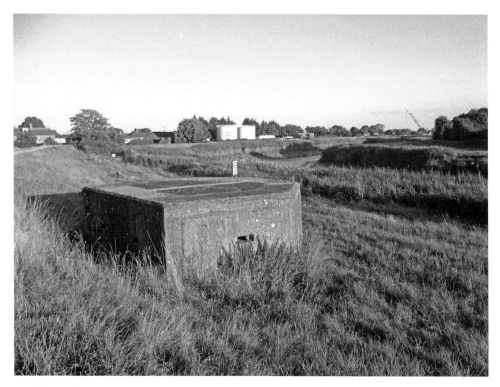

A pillbox at the entrance to Bridgwater Docks.

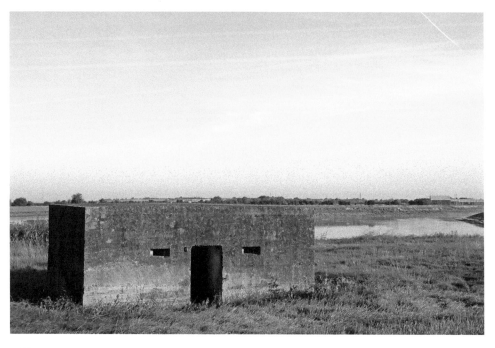

Pillboxes are scattered along the northern banks of the River Parrett.

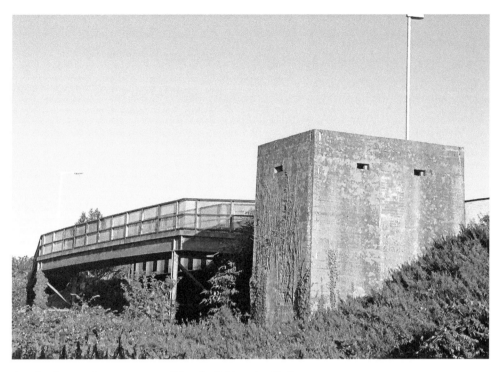

A rather impressive two-storey pillbox by Bridgwater Station.

Anti-tank cubes.

north of the town there are a number of pillboxes still standing on the banks of the River Parrett by the Express Park.

Bridgwater contributed a lot to the war effort as an industrial centre. The various local manufacturing units that existed in the town began producing a wide range of goods, with the cellophane plant leading the way by producing a protective film that could be used to encase ammunition and protect it from the heat and humidity of foreign theatres of war, such as North Africa and East Asia. Shell casings and components for tanks and landing craft were also created in the town. Bridgwater received relatively few air raids compared to other industrial centres across the country, but a number of incendiary and high-explosive bombs were dropped on the town, which resulted in some civilian casualties. Later in the war, Prisoner of War (POW) Camp No. 37 was established at Colley Lane – which is now an industrial estate – as well as POW Camp No. 44 on the outskirts of Bridgwater at Goathurst, with the captured Italian soldiers living in fairly good conditions and working on the local farms.

Bridgwater & Taunton Canal

The Bridgwater & Taunton Canal originally opened in 1827 linking the River Parrett to the River Tone. This 14-mile stretch of water was used in the Second World War as part of the defensive Taunton Stop Line. At over 12 feet wide, this man-made canal acted as an

The demolition chambers under the Huntworth Lane Bridge were filled in with concrete and bricks after the war.

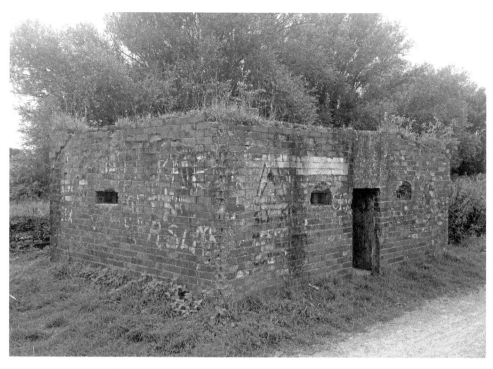

A large rectangular pillbox on the towpath of the Bridgwater & Taunton Canal.

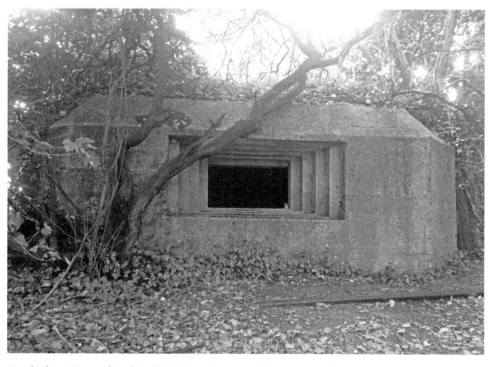

Overlooking Maunsel Lock is this Vickers heavy machine-gun emplacement.

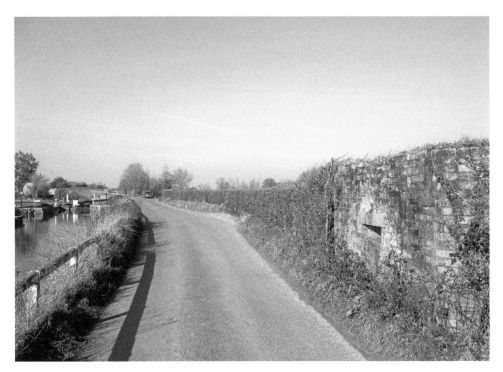

A pillbox just south of Stausland Lock.

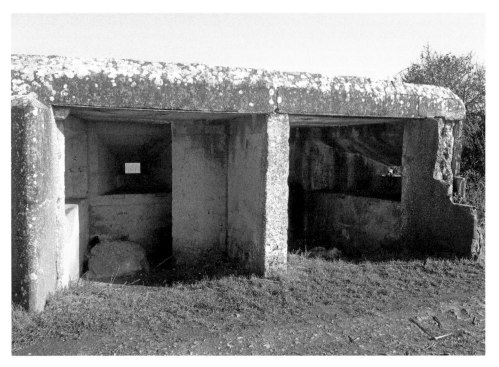

This partially destroyed pillbox allows you to appreciate the sheer thickness of the walls.

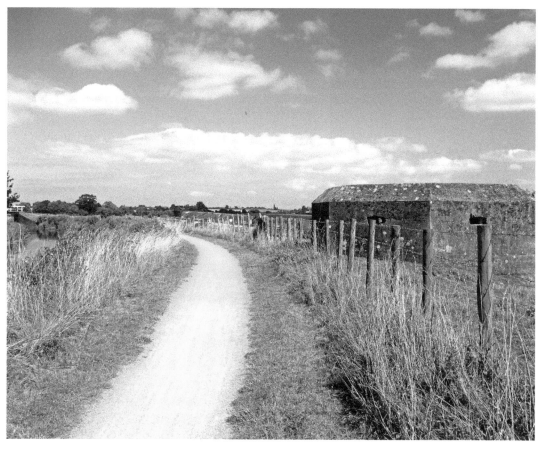

A strategically placed pillbox between the canal and rail track.

immoveable object that would need to be crossed by enemy forces. Pillboxes were placed at strategic points along the canal, often at turns, where their location would give them the element of surprise over any potential enemies coming around the corner, and all eleven of the existing brick-built permanent bridges were mined with demolition chambers that would be ignited should they look like being compromised. A gentle stroll along any of the miles of towpath is well worth it, with demolition chambers in bridges and a range of pillboxes and light machine-gun emplacements still easily visible along the whole route. The villages of Fordgate, North Newton and Charlton, along with the Maunsel Lock Canal Centre, all have emplacements still visible within their vicinity.

Burnham-on-Sea

The coastal town of Burnham-on-Sea has little by way of a military heritage, despite the Romans probably being the first to establish a settlement in the vicinity of Burnham when they began trying to reclaim the Somerset Levels. However, to the south of the town, at the mouth of the River Brue near Highbridge, there are a few pillboxes that were built during the Second World War. Situated just to the north of the Taunton Stop Line, these formed the start of GHQ Line Green, a static defensive line encircling Bristol,

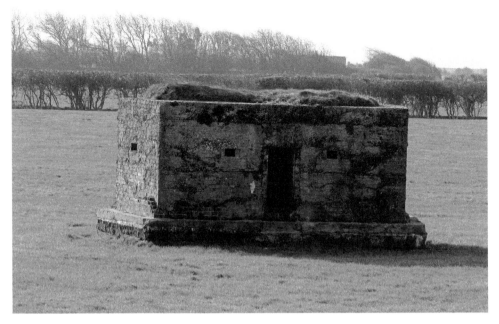

One of the many pillboxes of GHQ Line Green near Burnham-on-Sea. (Courtesy of Reading Tom under Creative Commons 2.0)

Avonmouth and Sharpness. Running east towards Wells, it heads into Wiltshire where it then moves northwards to Malmesbury and ends at Framilode in Gloucestershire. There are a number of defences along this route.

Burrow Mump
The historic site of Burrow Mump was given to the National Trust by Major Alexander Gould Barrett in 1946 to serve as a memorial to the men and women of Somerset who died during the Second World War.

Cannington
In Cannington, the Women's Land Army (WLA) had a training centre at Cannington Farm where these 'Land Girls' learned all the skills required for them to work in agriculture, as replacements for the men called up to the military. Brymore House was home to the US 535th Anti-Aircraft Battalion for a few months from February 1944 to May 1944, when they moved in preparation for their part in the D-Day landings.

Dunball Wharf
On the banks of the River Parrett, Dunball Wharf was used during the Second World war to unload supplies, particularly that of coal from Wales, to the nearby Royal Ordnance Factory (ROF) Bridgwater. The small industrial estate that exists today is on the site of the hostel accommodation that was built for single workers at ROF Bridgwater. There are also pillboxes stationed along the river banks, which remain in good condition.

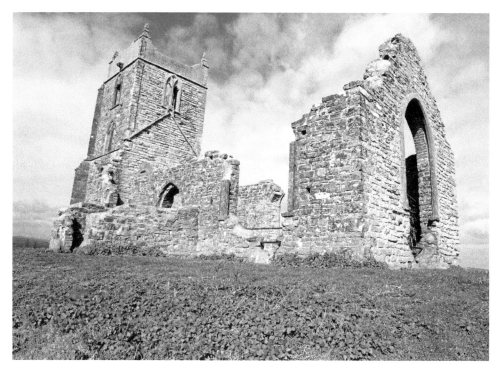

Burrow Mump. (Courtesy of Robert Cutts under Creative Commons 2.0)

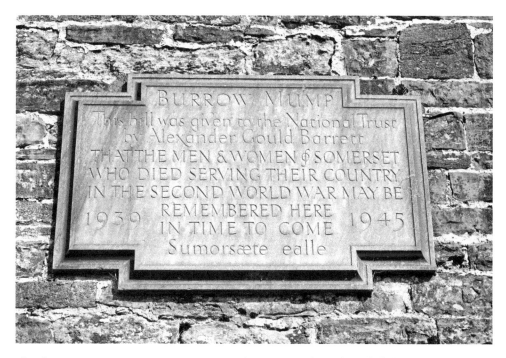

The plaque at Burrow Mump commemorates the service and sacrifice of all those from Somerset. (Courtesy of Robert Cutts under Creative Commons 2.0)

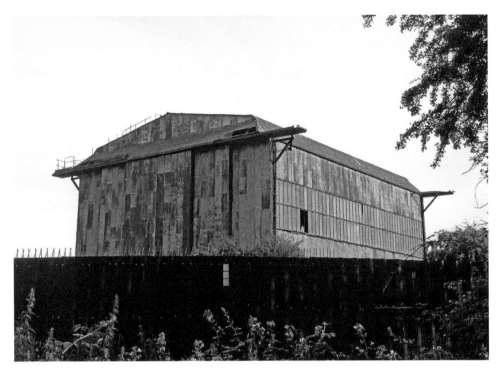

The huge hangar of the RAF research station at Pawlett.

Highbridge

Highbridge once boasted the control centre of the world's largest and busiest radiotelephony station, dubbed 'Portishead Radio', providing worldwide maritime and aeronautical communications. During the Second World War, the station was absolutely vital in maintaining contact and communication with the British Merchant Navy and patrol aircraft in the Atlantic. The station closed in April 2000 due to the prominence of satellite communication and, sadly, this piece of heritage is forever lost as the buildings were demolished in 2007 to make way for new housing. Highbridge is also the southern end of GHQ Line Green, a defensive line of pillboxes constructed during the Second World War running along the northern bank of the River Brue across empty fields towards Wells, southern Bath and into Wiltshire, designed to help repel a German invasion from the West Country.

Pawlett

The small village of Pawlett, just to the north of Bridgwater, was the site of an RAF research station into anti-barrage balloon warfare during the Second World War, due mainly to the vast expanse of open fields and the lack of people living there. A massive hangar over 30 metres long and 20 metres high was constructed so that the balloon, filled with a mixture of hydrogen and air, would not need to be deflated each night, and that repairs and maintenance could easily be carried out. The experimental work continued here until 1944, with the test pilots flying their aircraft into the cables to test the effectiveness of a range of cutters. The hangar, defensive pillboxes and the

The remains of a navigation beacon on the Pawlett Wetlands Reserve.

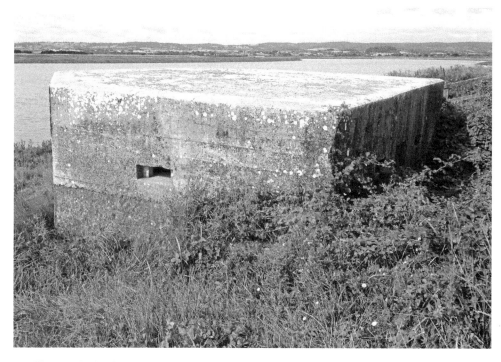

A pillbox on the banks of the River Parrett near Pawlett.

The site of ROF Bridgwater is off limits to the public.

partial remains of a navigation beacon on the Pawlett Wetland Reserve still survive to this day.

Puriton

Just to the north-west of Bridgwater by the village of Puriton lie the remains of the gigantic 700-acre ROF Bridgwater, which was a vitally important factory producing high explosives for munitions. Construction work began in 1939 on the orders of the Ministry of Supply, and by August 1941 the factory was producing RDX, an experimental new explosive more powerful than TNT, which was widely used by all sides throughout the remainder of the war. The factory had its own railway branch line and the workers for the factory lived in the nearby villages of Woolavington and Dunball. The factory required a year-round supply of an incredible 4.5 million gallons of water per day, so the existing artificial drainage channel 'King's Sedgemoor Drain' was widened and a new 5-mile straight channel was excavated, known as the 'Huntspill River', which is now a designated nature reserve. After the war, the site continued to produce a range of explosives before being privatised in 1985 and closing in 2008, when the buildings were demolished.

Sir Robert Blake

One of England's most revered admirals, Sir Robert Blake was born in Bridgwater and his legacy lives on with streets, shops and schools named in his honour. Nicknamed the 'Father of the Royal Navy' for his part in founding England's naval supremacy, he was born in 1598 and attended Bridgwater Grammar School for Boys before being elected

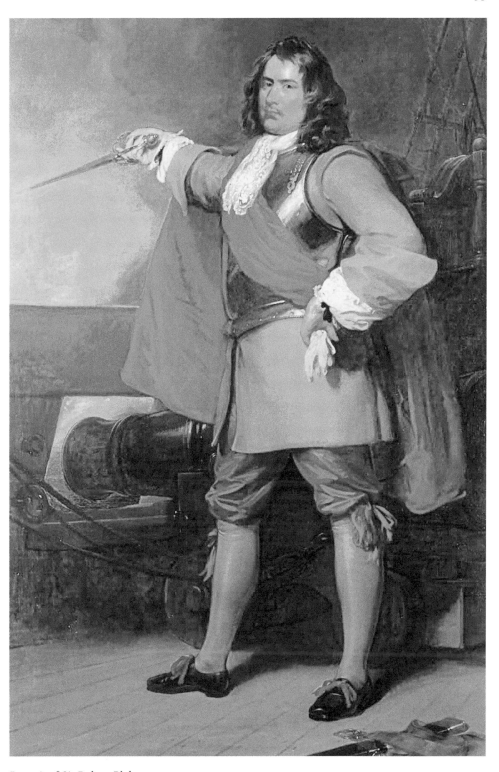

Portrait of Sir Robert Blake.

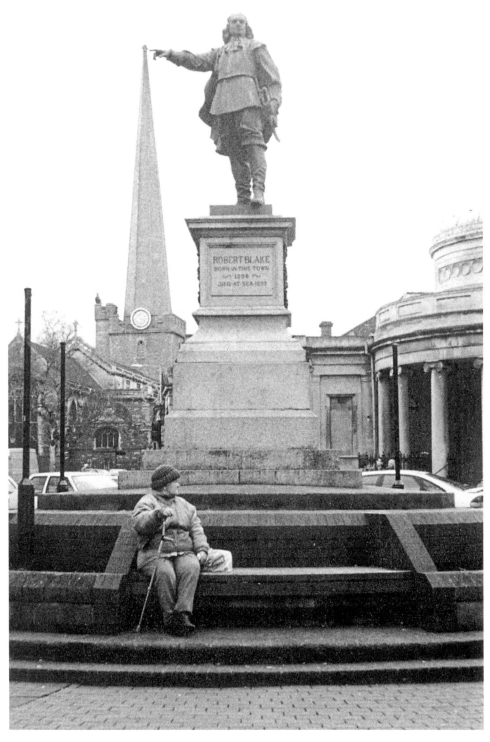

A statue of Bridgwater's famous son, Sir Robert Blake, takes pride of place in the town centre. (Courtesy of Rayray under Creative Commons 3.0)

Member of Parliament for Bridgwater in 1640. When the English Civil War broke out in 1642 he joined the Parliamentarian Army, despite having no military experience, and excelled during the sieges of Bristol, Lyme Regis, Taunton and Dunster. Following this, he became a 'General at Sea' in 1649 and amassed the biggest navy that had ever been seen – from a few ships in the Parliamentarian navy to over 100! In 1651 he took the Isles of Scilly, which had the last remnants of the Royalist navy, and over the next six years he led his fleet to victories in the Anglo-Dutch War and the Anglo-Spanish War. Sir Robert Blake died in 1657 having developed new techniques in maritime warfare as well as writing the navy's first set of rules: The Laws of War and Ordinances of the Sea. Blake was so revered that he was given a full state funeral and buried in Westminster Abbey in the presence of Oliver Cromwell, although his body was exhumed and reburied in St Margaret's churchyard four years later under orders of the newly restored monarchy.

Westonzoyland

Westonzoyland, a village on the outskirts of Bridgwater, has an impressive military heritage. It was here on 6 July 1685 that the last battle fought on English soil took place: the Battle of Sedgemoor. After a series of fights and skirmishes across the south-west of England, the 3,500–4,000-strong rebel force of James Scott, 1st Duke of Monmouth, became trapped in Bridgwater on 3 July 1685 by the royal army of James II. The 3,000-strong royal army led by Louis de Duras, 2nd Earl of Feversham, set up camp in a field behind the Bussex Rhine at Westonzoyland. Trapped and with nowhere to go, the Duke of Monmouth decided to get on the front foot and launched a surprise night time attack on the king's men. While navigating across the open moorland with its numerous deep and dangerous rhynes, some men startled a Royalist patrol, who in turn alerted the rest of Royalist force. It is no surprise that the professional training of the regular army defeated the ill-equipped rebels, with over 1,200 being killed, compared to approximately 200 of the king's men. Some 500 rebel soldiers were taken prisoner and held in St Mary's Church in the village. Other men were not so lucky, with those found to be hiding being strung up in gibbets along the sides of the village roads as a warning to all who questioned the rule of the king. After initially escaping, James Scott was soon captured in Hampshire and taken to the Tower of London, where he was beheaded. James II sent Lord Chief Justice Jeffreys to round up any of Monmouth's supporters, and tried them at Taunton Castle in the 'Bloody Assizes'. Most were found guilty, with the lucky ones being transported abroad and the rest executed.

Westonzoyland also boasts one of the country's oldest airfields. Constructed in 1925, RAF Westonzoyland was used sparingly in the first ten years of its existence, with planes towing targets for the anti-aircraft battery at Watchet to practise on being its main role, but towards the end of the 1930s the airfield was gradually enlarged. During the Second World War, the A372 was closed and diverted south in order to allow the airfield to be significantly upgraded to 'bomber standard', with three concrete runways and a whole range of associated buildings being added. With its new status as a 'Class A airfield', the United States Airforce (USAAF) took control and the 442nd Troop Carrier Group operated from the base, using the Douglas C-47 Skytrain to drop troops and equipment into northern France in the months after D-Day until October 1944. From this point until

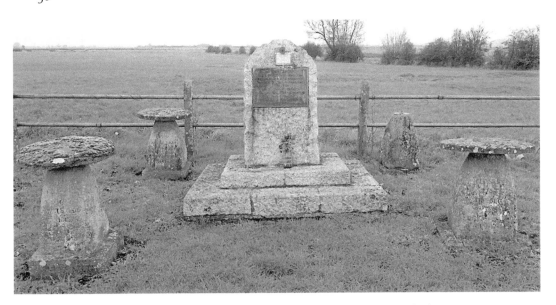

The memorial overlooking the empty field where the Battle of Sedgemoor took place.

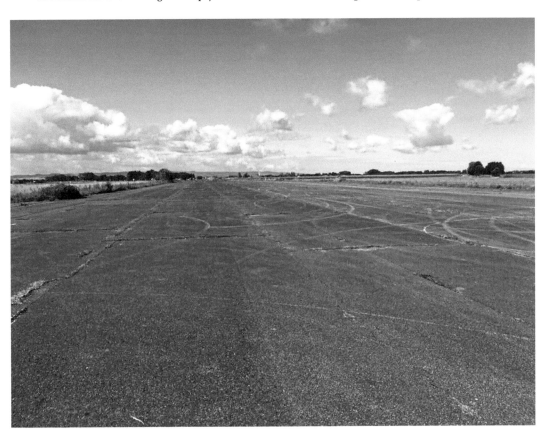

The runway at Westonzoyland is used today by microlights and for karting.

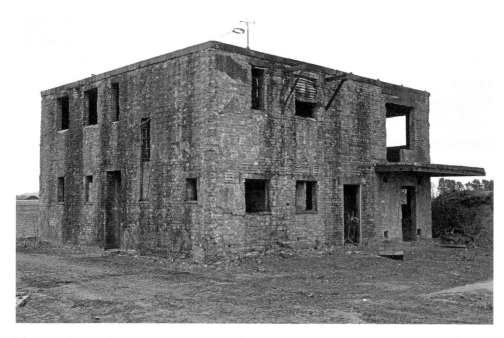

The ruined control tower at Westonzoyland still holds a commanding position over the site. (Courtesy of Richard E. Flagg)

the end of the war a number of RAF squadrons had brief stays at the airfield, with the village becoming accustomed to seeing a whole range of different aircraft coming and going. In the years after the war RAF Westonzoyland became largely redundant until the early-mid 1950s, when the Cold War threat saw the airfield once again in use as a training base for aircrews aboard Meteors and Vampires. By 1958 the airfield was once again disused, and when it was released from military use in 1968, the A372 was restored to its original location along the route of the main runway. Today, the runways are still evident at the site, as are the derelict remains of the control tower and a whole host of other buildings.

5. Mendip

Black Down Hill

Black Down Hill, part of the Mendip Hills and with Bronze Age burial mounds, was used during the Second World War as a bombing decoy site. Code named 'Starfish', the aim was to recreate the lights of Bristol and thereby encourage the Luftwaffe to drop its payload on the isolated hills instead of the city. Bunkers were built to house generators that powered the lighting of a 'poorly' blacked-out city. These decoy lights were arranged in six areas, designed to mimic the six areas of Bristol that were targeted, and later in the war, fires were created to simulate incendiary bombs hitting the city, trying to persuade the next wave of bombers to hit these targets. A 'Z-Battery' anti-aircraft battery was established, and with the fear of invasion in 1940, over 1,500 'tumps' (mounds of earth) were created to stop enemy aircraft landing. The command bunkers and tumps are still accessible from Tynings Farm.

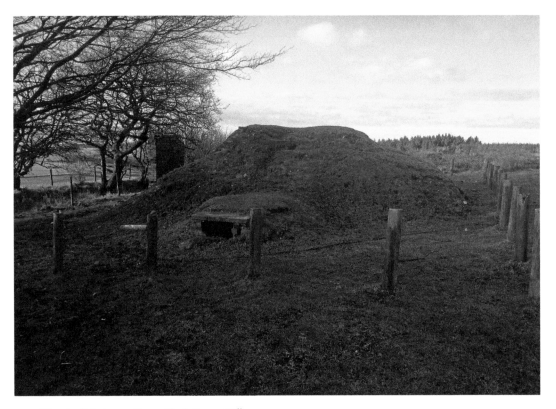

The starfish decoy site on Black Down Hill.

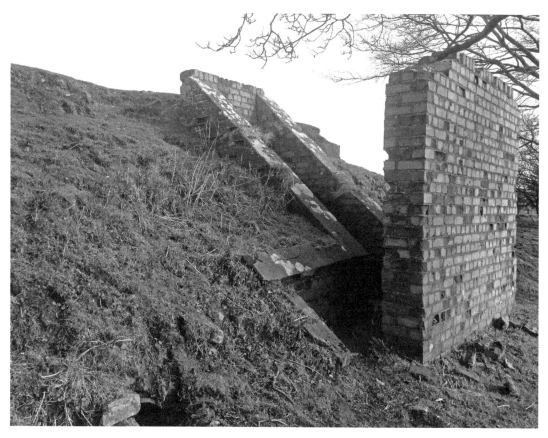

The entrance to the mound has a covering wall.

Charterhouse

The remote area of Charterhouse on the Mendips holds the distinction of being the site of the first enemy aircraft shot down in Somerset during the Second World War. All the crew of the German plane survived and were captured by the Charterhouse Home Guard, who in turn handed them over to the soldiers stationed at the nearby Yoxter Army Camp. Established in 1934 as a training base for the Territorial Army, it was used by the regular army at the outset of the Second World War, before reverting to the Territorial Army after 1945. It is still in use today by the Regular Army, Royal Marines, TA and the Army Cadet Force.

Nunney

The ruined castle of Nunney, located in the village of the same name, was built in 1373 on the site of a manor house. It is essentially a tower keep surrounded by a moat and was constructed by Sir John de la Mare, a local knight, in response to the possibility of a French invasion. This never happened and the castle was used as an impressive home, receiving various redesigns over the years. At the start of the English Civil War in 1642 a Royalist army was garrisoned at Nunney Castle, and in 1645 a Parliamentarian army opened fire with cannons in an offensive that breached the castle walls and forced those

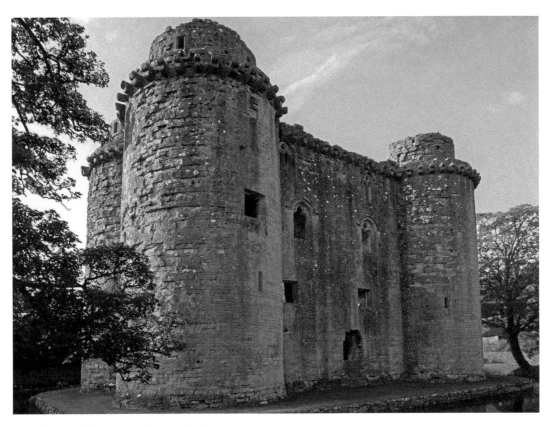

The visually stunning Nunney Castle.

inside to surrender. This was the only real military action that Nunney saw, with the castle swapping hands numerous times over the next few hundred centuries, gradually falling into a state of ruin. Today, the ruined shell is maintained by English Heritage, with the site free to visit all year round.

Shepton Mallet

In the aftermath of the Monmouth Rebellion in 1685, twelve local men from Shepton Mallet were hanged and quartered in the town's Market Place as a warning to others opposed to the king. Shepton Mallet's historic prison is the other unlikely contributor to the town's military heritage. Opened in 1625, it was used right up until the 1930s, primarily for civilians, when it was temporarily closed due to low prisoner numbers. However, at the outbreak of the Second World War it was reopened for British military use, mainly to billet soldiers, but was then handed over to US forces in 1942, who for the next three years used it to incarcerate military personnel who had committed offences. During this time, eighteen service personnel were executed inside the prison. At the same time in a different part of the prison, and unbeknown to most, a number of important historical items from the Public Record Office in London were transported

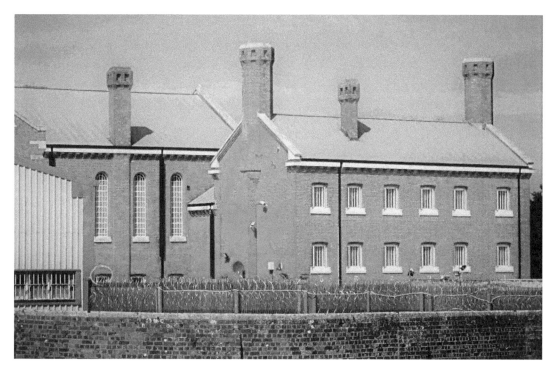

HMP Shepton Mallet.

here for their safekeeping during the conflict. Items including the Domesday Book, a copy of the Magna Carta, letters from the Battle of Waterloo, and the logbooks of HMS *Victory* were held here until the end of hostilities.

Wells

The beautiful city of Wells started out as a Roman settlement and has spent much of its existence closely linked to the bishops of Bath and Wells and the cathedral. During the English Civil War the city of Wells was entirely surrounded by Parliamentarian forces, who viewed the city as a prize capture, and forced the Royalists to leave the city. It is rumoured that they proceeded to use the cathedral to stable their horses and damaged some of the sculptures by using it for target practice. Wells was again the focus of much activity during the 1685 Monmouth Rebellion, where rebels fighting against the king saw the grand cathedral as a symbol of all that was wrong with the 'established order' and attacked it, breaking windows, destroying the organ and using the lead roofing to make bullets. The king's retribution was swift, and Judge Jeffries held the last of his 'Bloody Assizes' at Wells where over 500 of the rebels were put on trial for treason. Lasting just one day, the vast majority were found guilty and sentenced to death. In the Second World War, Stoberry Park was Prisoner of War Camp No. 666, where both German and Italian prisoners were held and in College Road the original stone gateway remains. There was a second POW camp on the outskirts of Wells.

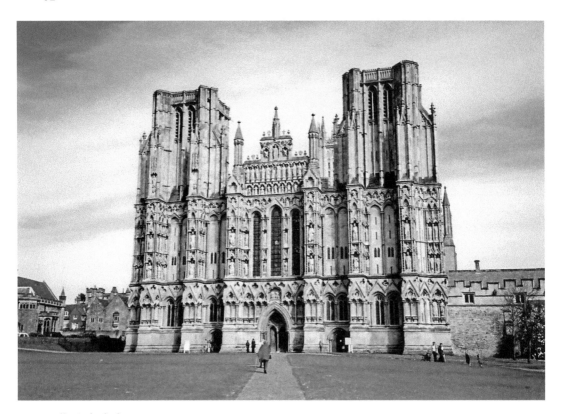

Wells Cathedral.

Wookey Hole

Towards Wookey Hole, on the outskirts of Wells, Penleigh Prisoner of War Camp was an Italian working camp where its inmates helped work the land. There is also the mound that was once the location of Fenny Castle, a wooden motte-and-bailey castle thought to have been built in the twelfth century.

6. Taunton Deane

Bishops Lydeard

Sandhill Park, on the outskirts of Bishops Lydeard, was used during the First World War as a prisoner of war camp for captured German troops, and used by the military in the Second World War as the 41st General Military Hospital, with tents and huts being erected in the grounds. These temporary buildings were taken down after the war and the country house now sits derelict.

Churchstanton

Churchstanton, a small village on the Blackdown Hills, was home to RAF Culmhead during the Second World War. Originally named RAF Church Stanton after the nearby village, it began operations in 1941 with three tarmac runways and a number of hangars being built. Over the next two years Polish and Czech squadrons occupied the airfield.

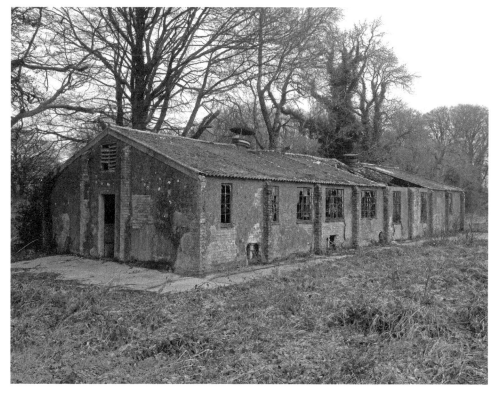

One of the Flight Offices still standing at RAF Culmhead.

One of five sets of aircraft fighter pens.

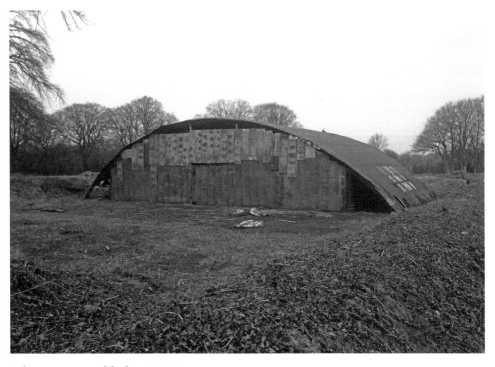

A hangar, now used for hay storage.

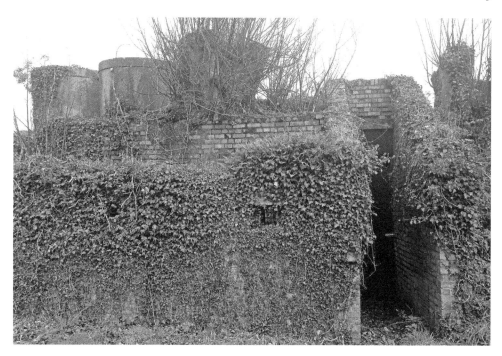

The extensive site of RAF Culm Head.

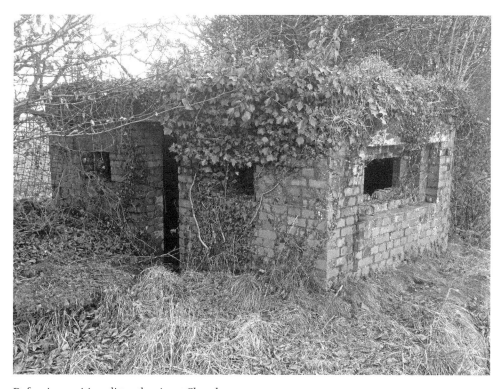

Defensive positions litter the site at Churchstanton.

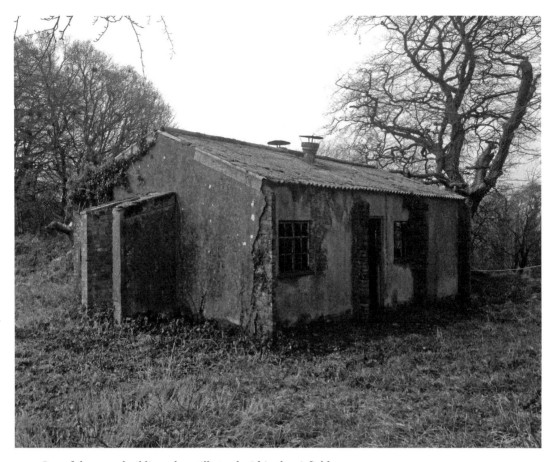

One of the many buildings that still stand within the airfield.

In 1943 the base was renamed RAF Culmhead to avoid radio confusion with RAF Church Fenton in Yorkshire. Aircraft continued to participate in operations for the remainder of the war, with No 131 Squadron flying their Spitfires from Culmhead to Normandy on day one of the D-Day landings. In July 1944, RAF Culmhead became the first base within the allies to have jet-powered aircraft on site, with the arrival of two Gloster Meteor Mk I's. After 1945 the airfield was used for glider and aircraft maintenance training until it was closed in 1946. Today, the site is used as an industrial estate with quite a lot of the original buildings remaining in derelict condition. The control tower, hangars and fighter pens, as well as a myriad of pillboxes and other buildings, are easily accessible on the site via public footpaths.

Creech St Michael

The village of Creech St Michael, just to the east of Taunton, was the third so-called 'defensive island' of the Taunton Stop Line in the Second World War due to the fact the Bridgwater & Taunton Canal and the River Tone pass within 200 metres of each other at the centre of the village. As a result, Creech St Michael had a number of anti-tank

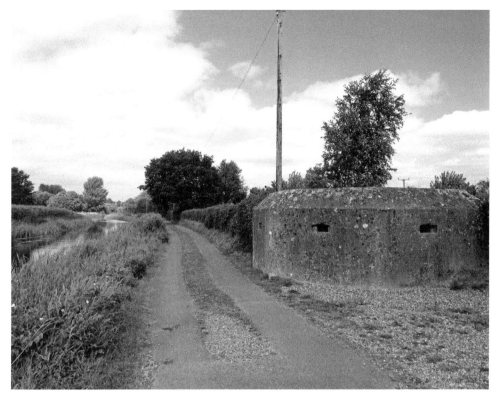

The pumping house at Creech St Michael was protected by a pillbox.

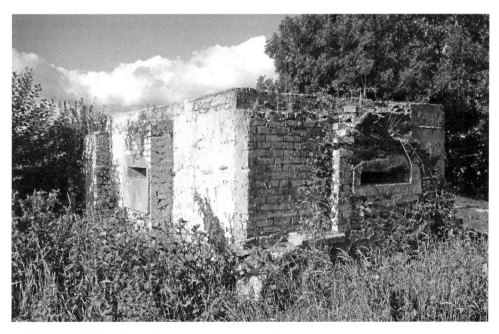

A pillbox overlooking the Bridgwater & Taunton Canal.

The demolition chambers under the St Michael Bridge are still clearly visible.

defences positioned by the two waterways and the railway tracks in the hope that they, together with the Home Guard unit made up of local volunteers, would be able to defend the village and its vital transport connections. On the outskirts of the village 'The Old Engine House' used to pump water from the nearby River Tone into the canal, and a pillbox was built right outside it in order to defend the pump house from attack. You can still see the demolition chambers under the St Michael Road Bridge in the middle of the village, and there are a vast number of pillboxes in good condition dotted around the village.

Taunton

It is unsurprising that the county town of Taunton has a significant role to play in Somerset's military heritage. There is evidence of Bronze and Iron Age settlements, and the Anglo-Saxons constructed a defensive building that later became an Augustinian priory. In the early twelfth century, the Bishop's Hall was converted into a small castle, and by 1138 it had grown into a significant stronghold. The Barons Revolt of 1216 was successfully defended against at Taunton Castle, and over the next century the keep is thought to have grown in size to 20 metres by 30 metres. The son of Simon de Montfort, the man who led a rebellion against Henry III in the Second Barons War, was held prisoner within its walls for a number of years. As styles changed during the Tudor era

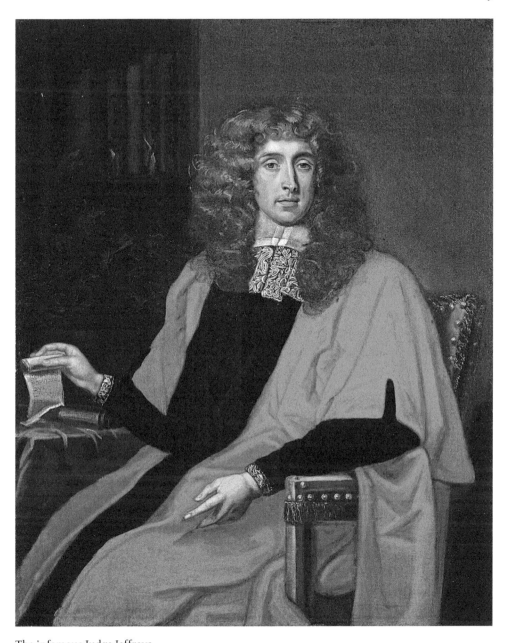

The infamous Judge Jeffreys.

so did the castle, with buildings being added and modified until the castle began to lose its defensive significance and took on the role as more of a grand show of power.

However, by the First English Civil War in the 1600s it had been re-established as a defensive site by the Royalist troops because of its strategic importance controlling the main road from Bristol to the West Country. By September 1644 Parliamentarian forces under the command of Colonel Sir Robert Pye and Robert Blake surrounded the town and

claimed it without any fighting and held it until 1645, in which time Royalist armies had laid siege to the town on no less than three occasions. In September 1644, Royalist troops from around Somerset converged on the Parliamentarian forces in the area and forced them back into the grounds of Taunton Castle, where they blockaded them with the aim of starving Blake and his troops into submission. They held out and by December 1644 a second Parliamentarian force joined them, forcing the Royalist troops to drop the blockade and move away. They returned in March 1645 to find some earthwork defences and small forts in place around the town and fierce fighting took place, forcing the Parliamentarian troops to once again move back to the safety of the castle. The Royalists were unable to break through the perimeter defences of the castle despite repeated attempts, and were themselves forced to retreat from the town when another Parliamentarian army turned up just in time as supplies within the castle dwindled. By May 1645 the Royalists returned with a large army of over 10,000 troops and besieged the town for a third time. Despite their numbers, the Royalist siege was fairly lax and allowed supplies into the town. The Parliamentarian troops inside the town kept the Royalist force at bay for over two months, occupying them when they could have been deployed elsewhere in the country by King Charles. By July, a third Parliamentarian relief force headed to the town, making the Royalists withdraw yet again. It is thought that over half the town was destroyed during this time and less than twenty years later, the Royalists got some sort of revenge, with the infamous Judge Jeffreys using the Great Hall at Taunton Castle to conduct his 'Bloody Assizes'. In September 1685, in the aftermath of the failed Monmouth Rebellion, over 500 supporters of James Monmouth were tried, resulting in over 140 being hung, with their remains being displayed in the town, and across the county, as a warning to others.

For the next hundred years or so, the castle was used as a prison but fell into a state of disrepair. Thankfully the Member of Parliament for Taunton in 1786, Sir Benjamin Hammet, began restoring the castle and a century later, in 1873, the Somerset Archaeological and Natural History Society purchased the castle and restored the Great Hall. Today, Taunton Castle is home to the Museum of Somerset and the Somerset Military Museum.

Elsewhere in Taunton, overlooking Vivary Park is the huge keep of the Jellalabad Barracks, which were built in 1881 by the Ministry of Defence. This military depot became home to the Somerset Light Infantry, who had four battalions under its control. Elements of this unit were in action in India and the Second Boer War, and in 1912 their name changed to the Prince Albert's Somerset Light Infantry. At the outbreak of the First World War, thousands enlisted at Jellalabad Barracks and they saw service on the Western Front as well as in Iraq and Palestine, with almost 5,000 men losing their lives during the conflict. In 1921 their name changed again to the Somerset Light Infantry (Prince Albert's) and by the outbreak of the Second World War, the regiment had eleven battalions ready for service. Men from here fought in Burma, Italy, Greece and in North West Europe, participating in D-Day and the battle for Normandy. Elements were also responsible for defending some of the airfields within the county, such as at RAF Culmhead. After the Second World War, the regiment saw more overseas service in Germany and the Suez Crisis, until they were amalgamated with the Duke of Cornwall's Light Infantry in 1959 to form the Somerset and Cornwall Light Infantry. The regiment saw five soldiers receive the Victoria Cross over the

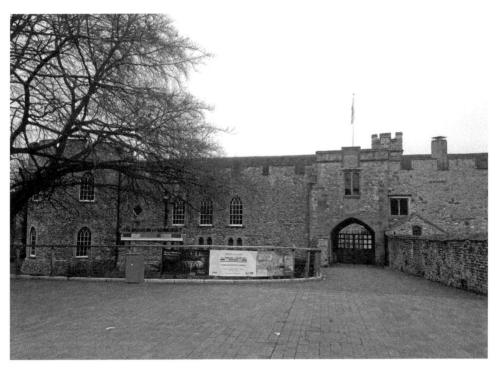

The Museum of Somerset is now housed in what remains of Taunton Castle.

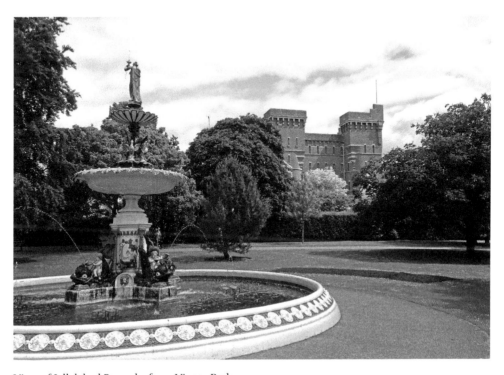

View of Jellalabad Barracks from Vivary Park.

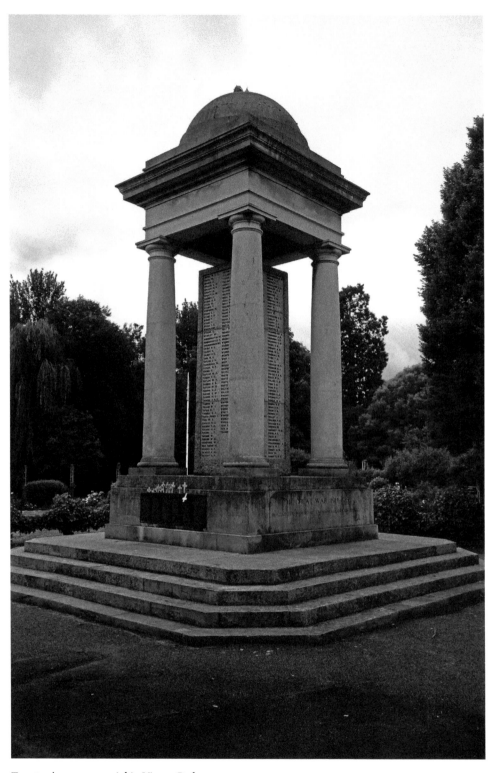

Taunton's war memorial in Vivary Park.

course of its history, the highest award for gallantry, one of which was to Tiverton-born Thomas Sage during the First World War. The depot closed and only the keep remained as the Regimental Pay Office. The vast majority of the site was redeveloped for housing, with only the impressive keep remaining.

One of Taunton's more interesting remnants of military heritage is Musgrove Park Hospital, which started its life as the US Army 67th General Hospital during the Second World War in 1941. The US Army Medical Corps developed the site and began receiving its first casualties of war in 1942. Many soldiers invalided back from Normandy after the D-Day landings passed through here, and after the war the decision was made to keep the facilities built by the US Army, with the hospital becoming part of the fledgling national Health Service.

To the north of Taunton, Walford House and its vast grounds became a large tented military camp for hundreds of American troops during the Second World War. They remained there from 1942 until just before the D-Day landings of June 1944, and it is said that when they left their convoy stretched for over 4 miles from Walford Cross to Henlade. After this, Italian prisoners of war were held within the grounds until around 1945, when they were replaced with German prisoners of war. Both sets of POWs were taken each day to help construct the Kings Sedgemoor Drain, just north of Bridgwater.

Further north of Taunton, Hestercombe House was the district headquarters of the US Services of Supply during the Second World War. Within this grand setting, everything the US troops required was sorted out.

Norton Fitzwarren

A few miles to the north-west of Taunton lies the village of Norton Fitzwarren, which is home to Norton Manor Camp, and base to 40 Commando, Royal Marines. The land was originally owned by Norton Manor but was redeveloped at the start of the Second World War by the British Army as a major logistics centre. The Royal Army Service Corps began using this new site in 1941, but it was soon handed over to the United States in 1942 to be used as one of their supply depots right up until the end of the war. To the north of the site, the Cross Keys Prisoner of War Camp No. 665 was established in 1941, holding low security risk Italian and German prisoners. After the war, the camp was returned to the British Army who continued to use it for the next twenty years as one of their main overseas supply depots, due to the significant facilities that were developed by the Americans. In the mid-1960s the depot was closed and the site was used as an army training base up until 1983, when parts of the camp were sold off for redevelopment as a trading estate and housing. However, the Royal Marines of 40 Commando moved in to the remaining part of the original camp, utilising the nearby territory of the Blackdown and Quantock Hills for training, and as such, Norton Manor Camp is still in use today. Most recently, over 600 personnel were deployed to Helmand province of Afghanistan as well as providing humanitarian assistance to various locations around the world.

Pitminster

During the Second World War the area around the village of Pitminster was used as a training area and rifle range for many troops in the build up to the D-Day landings.

The Nissen huts of the POW camp at Norton Fitzwarren.

Staple Fitzpaine

The earthwork remains are all that remain of Castle Neroche, a Norman motte-and-bailey castle built near the village of Staple Fitzpaine. There is evidence to suggest that the motte was over 6 metres high, but none of the wooden castle defences are left. Part of the Blackdown Hills, it is located in a public forest.

Wellington

The small town of Wellington is an interesting inclusion as the town is named after Arthur Wellesley, 1st Duke of Wellington, who helped defeat Napoleon at Waterloo and is regarded as one of Britain's finest military leaders.

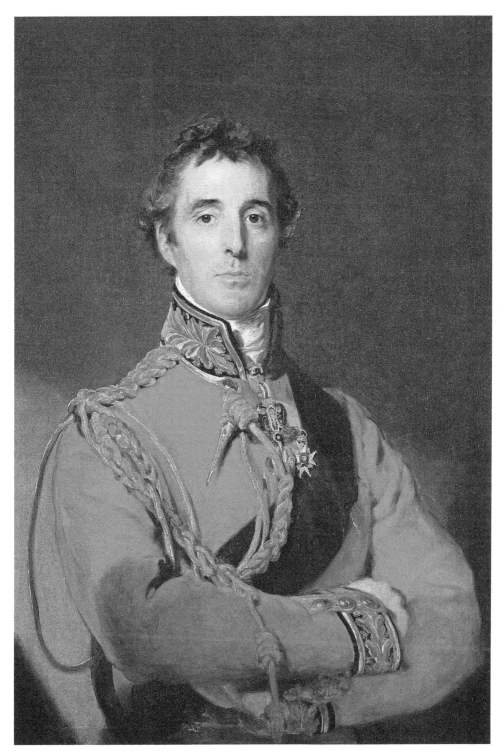

Portrait of the Duke of Wellington.

7. South Somerset

Barwick

The village of Barwick on the Somerset-Dorset border was once host to Prisoner of War Camp No. 405 within the grounds of Barwick Park. Initially housing Italian prisoners, it later saw German prisoners in the months that followed D-Day and right up until the end of the war. All traces of the camp were demolished and it is now parkland.

Cadbury Castle

Cadbury Castle is an Iron Age hill fort around 5 miles from Yeovil that still has its terraced defensive earthworks in situ. It is thought to have been later used by the Romans as a military barracks and refortified in the Middle Ages. Intriguingly, the site was once known as 'Camalet', with some believing that this is the site of King Arthur's Camelot.

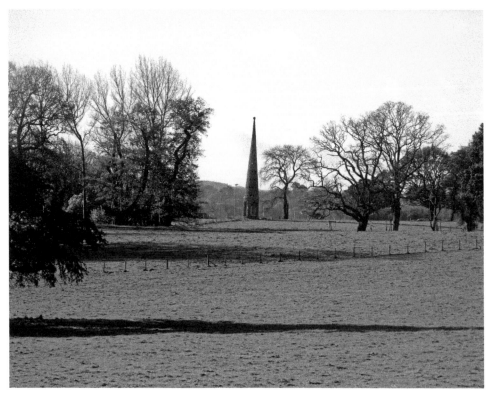

Barwick Park, site of a prisoner of war camp. (Courtesy of A Quiver Full of Fotos under Creative Commons 2.0)

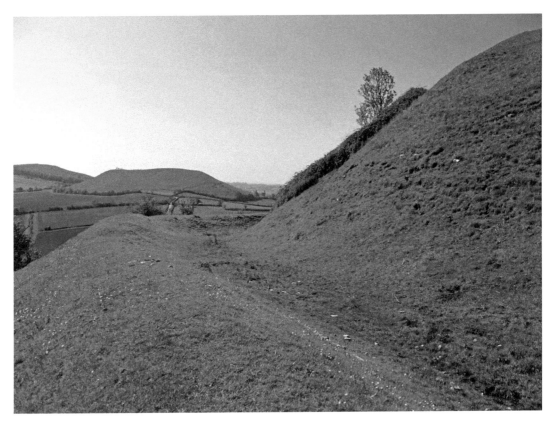

On the slopes of Cadbury Castle.

Castle Cary

Castle Cary is another village that boasts the remains of an old motte-and-bailey castle. Cary Castle was situated atop Lodge Hill and although there are only earthworks that remain, excavations carried out in the late nineteenth century suggest that a 24-metre stone keep once occupied the site.

Chard

Chard, the southernmost town in Somerset, was an unwitting footnote in the English Civil War when the town was significantly damaged and looted by both the Royalists and Parliamentarians in 1644. Just over forty years later Chard was one of towns used by the infamous Judge Jeffreys during the 'Bloody Assizes', where after the failure of the Monmouth Rebellion he sentenced many rebels to death, with some of the hangings taking place at Snowden Hill. During the Second World War, Chard was one of the defensive anti-tank islands of the Taunton Stop Line and had a range of obstacles and pillboxes. American soldiers of the US Army 12th Field Workshop were stationed at the Furzehill (sometimes referred to as Furnham) US Army Camp, which is now just a residential area. Interestingly, the branch of the Westminster Bank in Chard had a bombproof bunker that was used to store duplicate copies of the banks records from

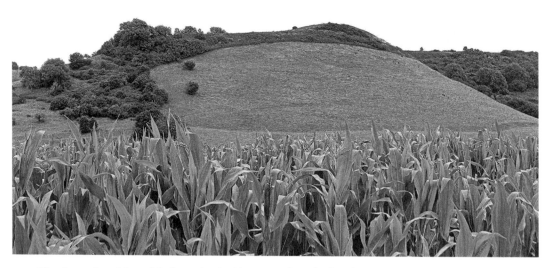

The elevated position of Cadbury Castle. (Courtesy of Hugh Llewelyn under Creative Commons 2.0)

There are hundreds of anti-tank posts around Chard Reservoir.

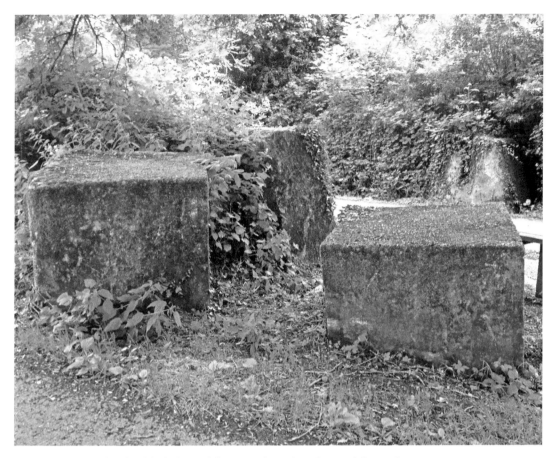

Huge anti-tank cubes block the path between the railway line and the road.

its head office in London, as well as the Bank of England's emergency banknote supply. A public lido was created on Chard Reservoir for recreational activities due to the fact that the vast majority of beaches along the south coast were out of bounds as they were barricaded with miles upon miles of barbed wire. There are still a number of anti-tank cubes and posts visible there today.

Charlton Horethorne

Charlton Horethorne is the site of a small airstrip built during the Second World War, primarily as a training centre for pilots and ground controllers. Operational between 1942 and 1948, some buildings are still visible today.

Crewkerne

There was once a Norman motte-and-bailey castle to the north-west of Crewkerne, of which only a ditch and some earthworks remain and there is a good condition pillbox left over from the Second World War near Wadham School.

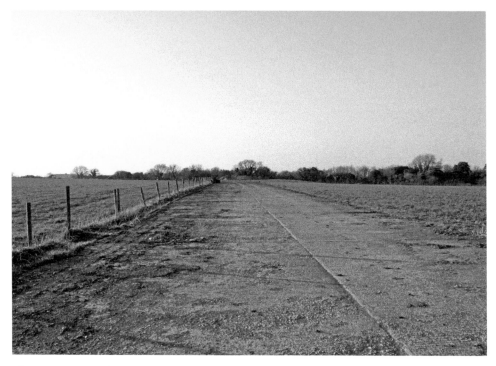

The runway at Charlton Horethorne. (Courtesy of Richard E. Flagg)

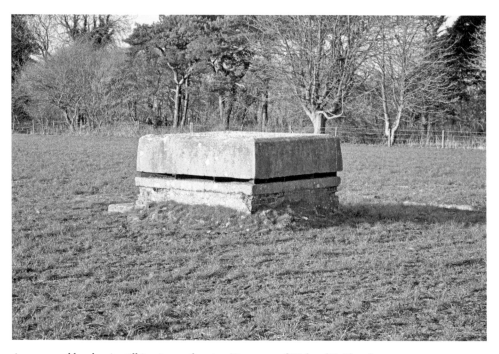

A command bunker is still in situ on the site. (Courtesy of Richard E. Flagg)

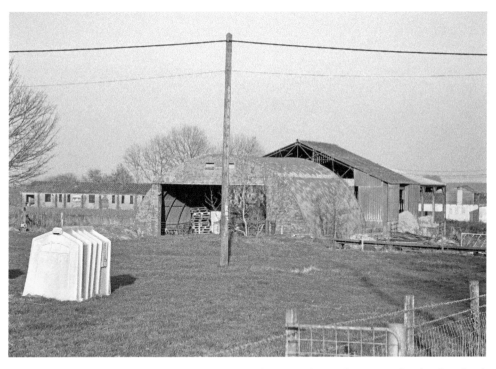

A hangar still stands in reasonable condition at Charlton Horethorne. (Courtesy of Richard E. Flagg)

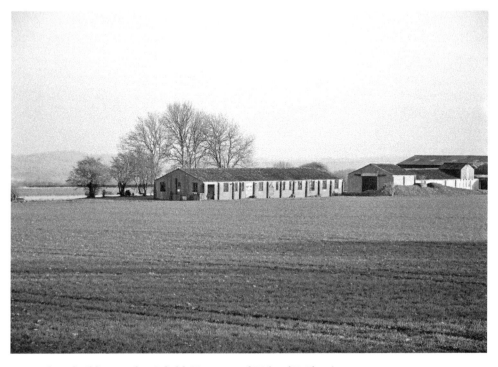

An auxiliary building on the airfield. (Courtesy of Richard E. Flagg)

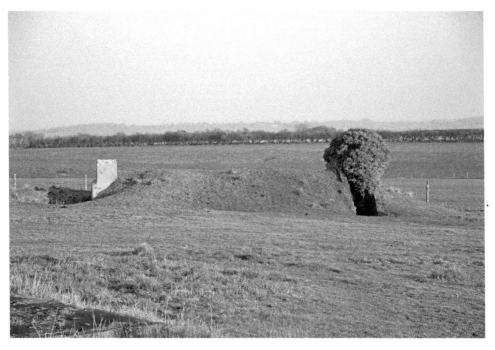

An air-raid shelter at Charlton Horethorne. (Courtesy of Richard E. Flagg)

A Second World War pillbox outside Wadham School in Crewkerne.

Cricket Malherbie

The Grade II-listed house Cricket Court at Cricket Malherbie was once owned by the press baron and owner of the *Daily Express* Lord Beaverbrook, who was good friends with Winston Churchill. He was given a number of cabinet posts during the war years, one of which was Minister of Supply, and Cricket Court was used as a secret meeting place for Prime Minister Winston Churchill and American General Dwight D. Eisenhower, who visited and stayed as guests of Lord Beaverbrook during 1944 while they were planning the D-Day landings.

Donyatt

The now idle single platform railway station at Donyatt has a number of Second World War emplacements surrounding it, and was used as an inspection point during the war to stop and check any trains using the lines between Chard and Ilminster. The station also saw a large number of evacuee children disembark on its platforms as they escaped the large industrial centres being targeted in the Blitz.

Ilchester

Ilchester, a few miles north of Yeovil, was once known as Lindinis and was the site of a prominent Roman fort where the Fosse Way crosses the River Yeo. Today, it is the home of

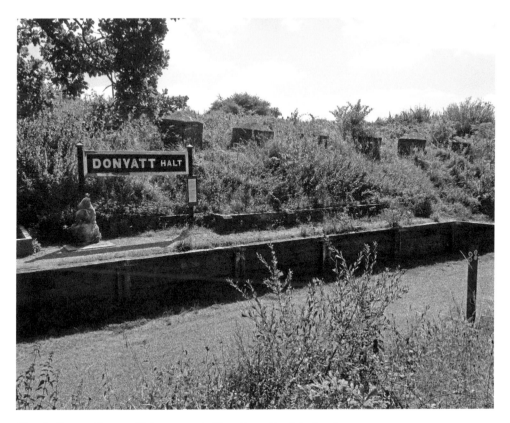

The platform at Donyatt Halt surrounded by a line of anti-tank cubes.

A roadblock at Donyatt Halt Station.

RNAS Yeovilton, a large 1,000-acre site that is one of only two active Fleet Air Arm bases in the country. Just prior to the Second World War, the Admiralty commandeered around 400 acres of land to establish an aerodrome, constructing four runways in extremely quick fashion. A range of activities took place from the site, from flying and gunnery practice to even marking up one of the runways to practise landing on an aircraft carrier. The airfield was subject to attacks from the German Luftwaffe in the first half of the war, although no substantial damage was ever done. After the Second World War, the runways were extended to allow jet aircraft access, and in the 1960s it became the home to the School of Fighter Direction. Yeovilton was the base of the Sea King helicopter and Sea Harrier. Today, the base is home to the Royal Navy Wildcat Maritime Force, Commando Helicopter Force and a number of training schools. Located at the edge of the site is the Fleet Air Arm Museum, which is open all year round, and the annual Yeovilton International Air Day attracts over 35,000 people each year.

Ilton
The village of Ilton was one of the designated 'anti-tank islands' of the Taunton Stop Line in the Second World War and would have had a vital role to play in defending the nearby

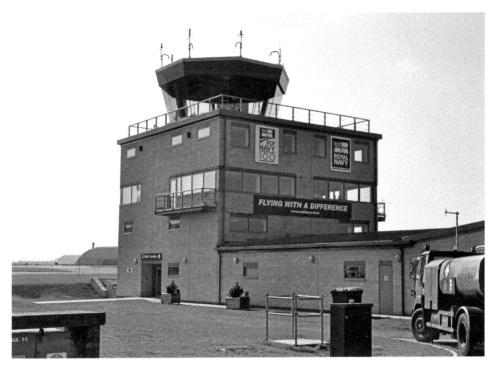

The control tower at RNAS Yeovilton. (Courtesy of Richard E. Flagg)

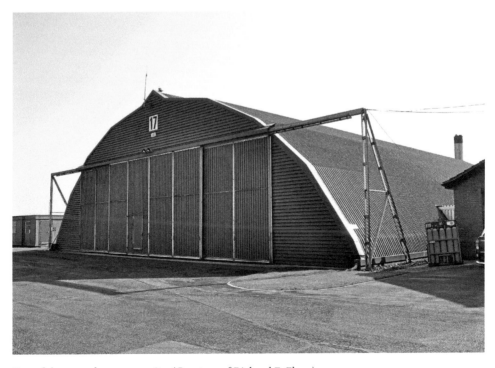

One of the many hangars on-site. (Courtesy of Richard E. Flagg)

RNAS Yeovilton is still an operational site. (Courtesy of Richard E. Flagg)

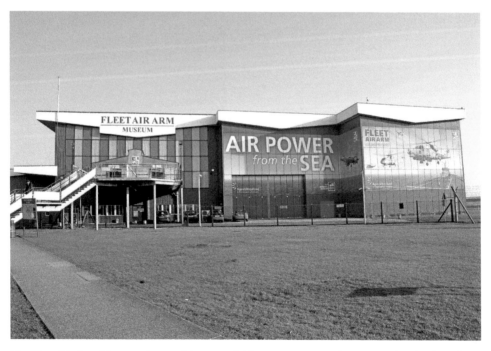

The Fleet Air Arm Museum is one of Somerset's biggest attractions. (Courtesy of Richard E. Flagg)

airstrip of RAF Merryfield. Around the southern perimeter of the village there are a few pillboxes and anti-tank cubes to be found lurking in the hedgerows.

Ilminster

Ilminster was the site of a small skirmish between Parliamentary troops and Royalist forces in the months leading up to the Battle of Langport in 1645. The town was also fortified as part of the local defences in the Second World War, but most traces have since been lost to urban development.

Knowle St Giles

Knowle St Giles, a tiny village that formed part of the Taunton Stop Line during the Second World War, is situated on the River Isle and has a road bridge that crosses the old Taunton–Chard railway. Defences were built within the vicinity of the bridge, with roadblocks, anti-tank cubes and pillboxes being constructed, along with a significant anti-tank emplacement that once housed a massive 6-pounder anti-tank gun. Members of the Royal Artillery were stationed here to man the gun, living in tents and cooking their own food, while during the cold winter months, they were billeted a few hundred metres away in the watermill building on the Manor Farm estate.

There are a number of defences around the Knowle St Giles road bridge that once went over the Taunton–Chard railway line.

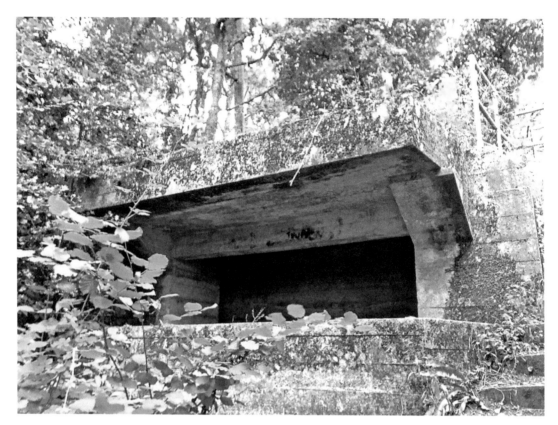

The 6-pounder anti-tank gun emplacement.

Langport

On 10 July 1645, the village of Langport on the Somerset Levels was the site of a hugely significant battle between the Royalists and Parliamentarians fighting it out during the First English Civil War. Won by the Parliamentarians, the Battle of Langport saw the Royalists lose their final enclave in the West of England. With the Royalists in retreat, outnumbered by their counterparts, and with their 7,000 men stretched over a front of 12 miles, they consolidated their position by occupying a strong defensive location to the east of the village. With a marshy valley and a single-track lane crossing the vast fields, the Royalist army under the command of Lord Goring held a ridge overlooking the area. However, the greater morale of the larger Parliamentarian army forced the Royalist army to flee, although not before setting fire to the village in an attempt to delay their pursuers.

RNAS Merryfield

To the north of the village of Ilton is RNAS Merryfield, an aerodrome built during the Second World War and still in use today as a training facility for helicopter pilots in the Royal Navy. Originally named RAF Isle Abbotts after the small village to the north, work began to create a Class A airfield suitable for use by heavy bombers. In 1943 the airfield's name was changed to RAF Merryfield after the estate it was built on, and in February 1944 it

was officially opened by the Royal Air Force. Soon after, the airfield was handed over to the United States Army Air Force to facilitate the movement of US troops during the final years of the conflict, and from this point activity in the area was significant. On D-Day, around 1,400 brave paratroopers set off from here and the airfield would have been a hive of activity for the next few weeks. By September 1944 the airfield stood empty as the US Air Force relocated to France, and since then it has been used for training purposes by the Royal Navy.

Montacute

To the west of the village of Montacute, Ham Hill is thought to have once been an Iron Age hill fort. Also on the village outskirts is the location of Montacute Castle, built in 1068 in the aftermath of the Norman Conquest, and centuries later replaced by a chapel as its defensive significance dwindled. In 1760 a folly tower known as St Michael's Tower was constructed in the same place and this is the only permanent structure that remains on the hilltop. St Michael's Hill and its significant earthworks are open to the public all year round.

Stocklinch

Stocklinch, just to the north-east of Ilminster, is the second Somerset village to be 'Doubly Thankful' as all those who served in both First World War and Second World War came home again safely. There is no war memorial here, instead a commemorative plaque stands outside the village hall, and inside the Church of Mary Magdalene there is a brass plaque that lists the names of the nineteen villagers who fought in the First World War.

Ham Hill war memorial. (Courtesy of Penganell under Creative Commons 2.0)

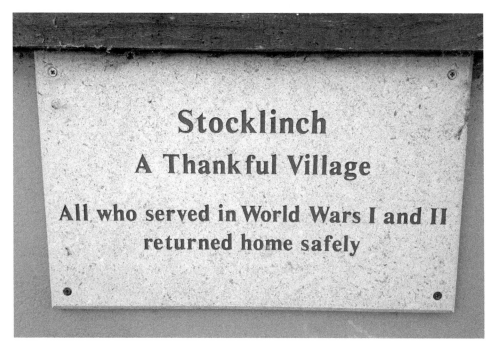

The plaque in the 'doubly thankful' village of Stocklinch.

Wincanton

Wincanton has quite an eventful past for a small town. Reported to have been the site of battles between the Saxons and the Danes, after the Norman Conquest of 1066 a number of motte-and-bailey castles were built in the area, with some earthworks of Cockroad Wood Castle, Ballands Castle and Castle Orchard still remaining. The latter part of the seventeenth century saw six men hung, drawn and quartered in the town in 1685, as James II took revenge against those who fought against him during the Monmouth Rebellion. On 20 November 1688 it was the scene of is said to be 'the last battle to take place on English soil from an invading army'. After landing in Devon, William of Orange from the Dutch Republic marched towards the forces of James II at Salisbury, where his small advance guard was met by a small patrol of the English army. The 'Wincanton Skirmish', as it is known, was one of only two armed skirmishes that year, with a handful of men being killed on both sides. In the early part of the nineteenth century, the town was used as a base for captured French officers from the Napoleonic Wars. More recently, Wincanton Racecourse was used during the Second World War as an American military base in the build up to D-Day.

Wrantage

The tiny village of Wrantage was the fourth of the so-called 'anti-tank islands' built during the Second World War as part of the Taunton Stop Line. Here, there are pillboxes and sections of an anti-tank wall still standing in the surrounding fields and up towards the Crimson Hill Tunnel. It is one of the longest tunnels in the country spanning a distance

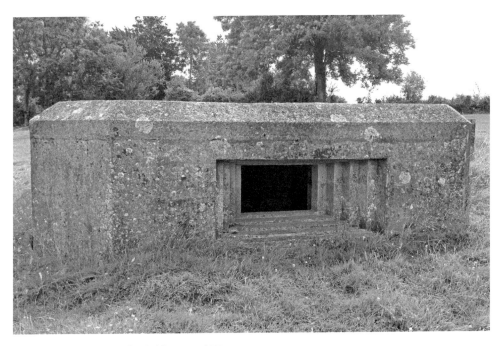

A gun emplacement in the fields around Wrantage.

Anti-tank cubes at the entrance to Crimson Hill Tunnel.

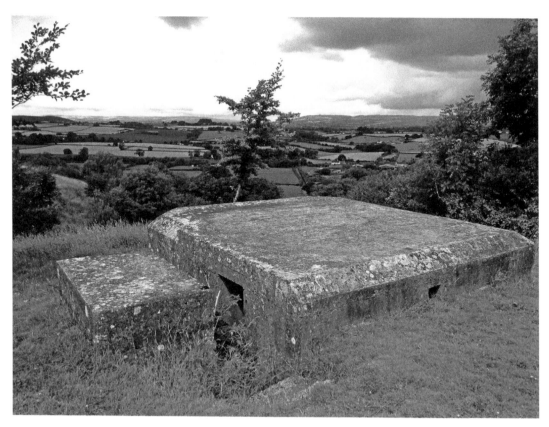

Stunning views from the light machine-gun emplacements on top of Crimson Hill.

of over 1,500 metres and is said to have been used for the storage of armaments in the 1940s. At the top of the hill there are two Vickers machine-gun casemates that have a commanding view of the surrounding countryside.

Yeovil

Yeovil is the final stop of this whistle-stop tour of Somerset. To the south-east of the town, a small skirmish known as the 'Battle of Babylon Hill' took place during the English Civil War, which saw the Roundheads pushing back the Cavaliers towards Sherborne. By the mid-seventeenth century much of the town's industry was related to the defence sector, particularly aircraft development, and this made Yeovil a target of the German Luftwaffe during the Second World War, resulting in fifty people losing their lives. Yeovil Aerodrome, also known as Yeovil/Westland, is less than a mile from the town centre and was unsurprisingly a principle target. The nearby industrial units produced and repaired a number of different aircraft, including Whirlwinds and Spitfires. Today, the helicopter manufacturers Leonardo Helicopters are still based in the town and the Aerodrome is still used for test flights. To the south of the town, Barwick Park was the

View of Yeovil Aerodrome.

location of a prisoner of war camp during the Second World War, although nothing now remains of the camp. The same can be said for Houndstone and Lufton army camps, who accommodated vast numbers of soldiers during the Second World War, but have now been totally demolished, with the Houndstone Business Park, Lufton Trading Estate and Huish Park, home of Yeovil Town FC, being built in their place. During the Cold War, the Royal Observer Corps (ROC) established their No. 9 Group Headquarters at Hendford Hill. Using a Second World War bunker originally built in 1941 by the ROC, facilities were upgraded to provide a control centre to the constant monitoring that was required. The site closed in 2001.

Remembrance

All across Somerset the final resting place for allied servicemen, civilian casualties and that of the enemy can be found in almost every church and graveyard. Nearly every town and village has its own war memorial to those it lost during the two world wars of the twentieth century, a permanent reminder of those who paid the ultimate price for our freedom.

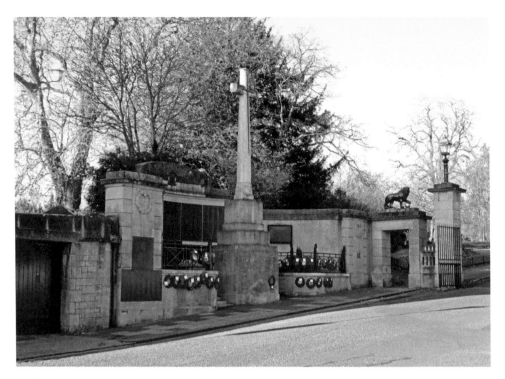

Bath war memorial.

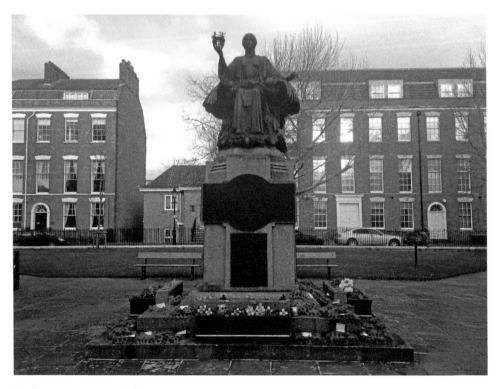

Bridgwater war memorial.

Acknowledgements

Researching the history of the place you live is an exhilarating and time-consuming process. Although I have lived in Somerset for five years now, I am still discovering new sights, sounds and stories. In this day and age it is possible to do a lot of research online, but nothing compares to actually heading out and exploring things for yourself. Only then, when you see the written history in its original environment, does it start to make sense. Investigating the different aspects of this book has led me to find out some incredible things and meet a number of wonderful people, all of whom have been willing to share the things they know, and this is so important in passing on the history of our communities to the next generation.

However, this book has not been without its challenges. Condensing 1,000 years of history at Dunster Castle into just 300 words, for example, is difficult, and inevitably I have not been able to write about every single aspect of some locations. Nor has it been possible to write about all the individual stories or events that have unfolded over the centuries. It has also been very difficult finding out about the older locations, such as Iron Age hill forts, as often there are no remnants of the structures (barring earthworks) or they have been built on top of due to their prominent location. Indeed, the Second World War features heavily as it is the most recent conflict and many of these structures used pre-existing features as its base.

I need to express my gratitude to Richard E. Flagg of UKAirfields.org.uk who has kindly allowed me to use some of his photographs in my book. His help and enthusiasm for photographing the county's airfields, and willingness to share, has been invaluable.
I would also like to thank Nikki Embery, Jenny Stephens, Marcus Pennington and all at Amberley Publishing for their help in making this project become a reality, as well as my wife Laura and young son James, who accompanied me on many wonderful day trips across the length and breadth of Somerset, a county with beautiful scenery and a rich military heritage.

All photographs have been taken by the author unless stated otherwise.

Also available from Amberley Publishing

THE WEST COUNTRY'S LAST LINE OF DEFENCE

TAUNTON STOP LINE

ANDREW POWELL-THOMAS

This fascinating book uncovers the remains of nearly 400 Home Guard emplacements scattered across Somerset, Dorset and Devon.

978 1 4456 6250 3

Available to order direct 01453 847 800

www.amberley-books.com